Introduction

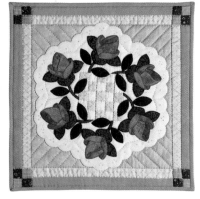

Create a floral delight for each month of the year with the patterns in this book. The methods used to create these same-size banners include paper piecing, appliqué and traditional or quick piecing. For more information on these methods see pages 60-64.

Practice your machine skills while making these quilted banners to fit a specially designed wooden hanger. Simply change the banner each month to add a seasonal decor to any room. We've even included instructions for making this wooden hanger on pages 58-59.

Meet the Designer
Jodi Glissmeyer Warner

Jodi Glissmeyer Warner finds inspiration for most of her captivating designs between 5 and 7:30 a.m. while her husband, Vince, and their three children, ranging in ages from 12 to 18 years, are still sleeping. Her studio is in her home in the rural/residential area of South Jordan, Utah, and she finds it a wonderful way to work. As the day progresses, she can enjoy executing her designs in fabric while interacting almost constantly with her family.

Jodi was raised in the Holladay community, southeast of Salt Lake City. She learned to sew at a very young age. She received a B.A. degree in textiles/fashion design from Brigham Young University in 1978 and began designing and making costumes for a theatrical studio and gowns for a bridal shop.

As a new homemaker Jodi found she enjoyed applying traditional patchwork and appliqué methods to the decorating needs of her home. She soon realized she had found a design arena that offered endless challenges and rewards.

Jodi has lectured, conducted workshops, taught at Salt Lake area quilt shops and mounted one-woman quilt shows in the intermountain West. She was an instructor for three years for a lifelong-learning curriculum through the University of Utah.

Jodi's quilts have won local, regional and national awards, most notably her Twelfth Night Tally, which won third place/professional appliqué at the 1993 competition of the American Quilter's Society. Her patterns and articles about her work have appeared in many magazines. She also owns her own pattern business, Hearthsewn, a natural outgrowth of the requests from students and area shops for formalized patterns of the designs she teaches. The company was established in 1986 and includes more than three dozen patterns, an annual Christmas stocking and patchwork clothing.

A current interest of Jodi's centers around a growing collection of quilts paired with children's storybooks which she uses to promote family literacy and quiltmaking awareness.

January Carnations

Start your year out right with a pretty wall quilt featuring a mitten full of flowers.

PROJECT SPECIFICATIONS
Skill Level: Intermediate
Project Size: 15" x 15"

MATERIALS
- Scraps light and dark red solids and light and dark green tonals, red print, white flannel and 8 cream/white prints or plaids
- ¼ yard blue/silver snowflake print
- ⅓ yard dark blue tonal
- Backing 20" x 20"
- Thin batting 20" x 20"
- All-purpose thread to match fabrics
- Contrasting quilting thread
- Clear craft glue
- 2 (½") red wooden beads
- ⅓ yard ⅛"-wide red decorative cord
- ⅛ yard fusible web
- Template plastic
- Erasable marker or pencil
- Basic sewing tools and supplies

Instructions
1. Prepare templates for K, L, thumb and mitten lining pieces using patterns given; cut as directed on each piece.

2. Make copies of paper-piecing patterns as directed. Cut pieces for heart section referring to Basic Paper Piecing on page 62.

3. Prepare all appliqué pieces referring to Basic Appliqué on page 60.

4. Cut two 2⅜" x 2⅜" squares each from the eight cream/white prints or plaids. Cut each square in half on one diagonal to make 32 A triangles.

5. Cut one 6½" x 6½" B square from one cream/white print or plaid.

6. Cut one 7¼" x 7¼" square blue/silver snowflake print; cut the square on both diagonals to make four C triangles.

7. Cut four 3½" x 3½" D squares blue/silver snowflake print.

8. Cut four 1" x 12½" E strips blue/silver snowflake print.

9. Cut four 3¼" x 3¼" squares blue/silver snowflake print (F) and six squares dark blue tonal (G). Cut each square on both diagonals to make 16 F and 24 G triangles.

10. Cut eight 1⅞" x 1⅞" squares blue/silver snowflake print; cut each square in half on one diagonal to make 16 H triangles.

11. Cut two 2¼" by fabric width strips dark blue tonal for binding.

12. Cut one 2½" x 4" J rectangle dark blue tonal.

13. Cut four 2" x 2" I squares red scrap print.

14. Cut one 2" x 3" M rectangle white flannel.

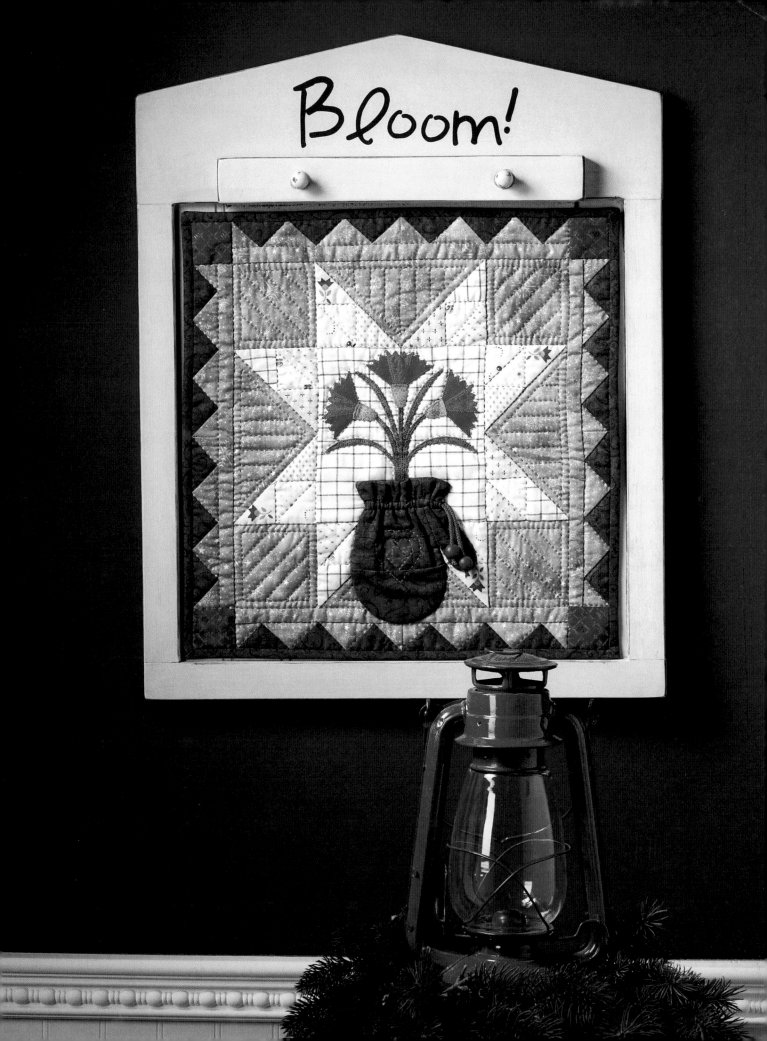

Completing the Pieced Background

1. Arrange and join four different A triangles to make an A unit as shown in Figure 1; press seams away from the center A triangle. Repeat to make four identical A units; then make four identical A units using the remaining four A prints.

Figure 1 **Figure 2**

2. Sew one of each type of A unit to the short sides of C to make four identical A-C units as shown in Figure 2; press seams toward A units.

3. Sew an A-C unit to opposite sides of B as shown in Figure 3; press seams toward B.

Figure 3 **Figure 4**

4. Sew a D square to each end of each of the remaining A-C units as shown in Figure 4; press seams toward D.

5. Sew an A-C-D unit to opposite sides of the A-C-B unit to complete the center piecing as shown in Figure 5; press seams toward B.

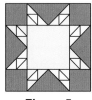

Figure 5

Completing the Pieced Top

1. Complete eight paper-pieced F/G/H sections using pieces F, G and H and referring to Basic Paper Piecing on page 62 and Figure 6.

Figure 6

2. Join two F/G/H sections to make a side strip as shown in Figure 7; press seam open. Repeat to make four side strips.

Figure 7

3. Sew an E strip to the F side of each side strip as shown in Figure 8; press seams toward E.

Figure 8

4. Sew a side strip to opposite sides of the pieced center as shown in Figure 9; press seams toward side strips.

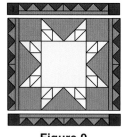

Figure 9

5. Sew an I square to each end of each remaining side strip; press seams toward I. Sew these strips to the remaining sides of the pieced center to complete the pieced background, again referring to Figure 9; press seams toward I side strips.

6. Remove paper pieces.

Completing the Appliqué

1. Arrange, fuse and stitch the appliqué shapes onto the pieced background referring to Basic Appliqué on page 60.

2. Complete paper-pieced heart using paper pattern and referring to Basic Paper Piecing on page 62.

3. Sew K and KR to opposite sides of the pieced heart section as shown in Figure 10; press seams toward K and KR.

Figure 10

4. Sew J to the top and L to the bottom of the K/heart section to complete the mitten piece as shown in Figure 11.

Figure 11

5. Place the M rectangle on the wrong side of the K/heart section; pin to hold. Hand- or machine-quilt in the ditch of the heart seams; trim flannel close to stitching.

6. Sew the thumb piece to the J/K/L section with right sides together, stopping and locking stitches at the dots to complete the mitten top as shown in Figure 12; press seam open. Repeat with the thumb and mitten lining piece.

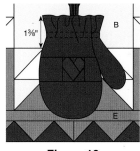

Figure 12

7. Layer the mitten top and lining pieces with right sides together and dots aligned; pin. Lock stitching at thumb dot, stitch around edge and lock stitching at the mitten dot.

8. Cut a 2" slit in the center of the lining piece; turn right side out through the opening and press.

9. Topstitch casing lines through both layers as marked on the lining pattern. Clip stitched seam at each end of the casing lines to make openings.

10. Insert one cord end through the casing. *Note: When the mitten is placed on quilt, one end of the cord will be placed behind the mitten to the other edge to look as if threaded through the casing.*

11. Set aside the 3-D mitten appliqué to attach after top is quilted and bound.

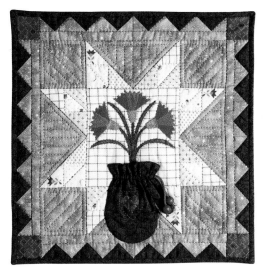

12. Refer to Completing Your Quilt on page 64 and the Placement Diagram for quilting suggestions to complete the quilting and binding.

Finishing

1. Center the bottom edge of the mitten at the E seam line with the top edge approximately 1⅜" into the B square as shown in Figure 13.

1⅜"

Figure 13

2. Cinch the cord in so the width at the casing measures approximately 2½".

3. Loop the cord extending from the left side of the casing under the appliqué and across so that the cord appears to be threaded through the casing. Pin outer edges of mitten in place.

4. Appliqué the edge in place, securing upper side edges at the top with extra stitches.

5. Leave the top of the mitten open; invisibly

stitch or glue the lining to the quilt at the lower edge of the casing. Tack through cords at casing outer edge to secure in place and prevent loosening.

6. Insert cord ends into painted beads. Knot one cord at 2¼" and the other at 2" beyond mitten edge; then ease the bead over the knot and glue to secure.

7. Trim excess cord ends ³⁄₁₆" and apply clear glue or nail polish to ends to prevent fraying to finish. ■

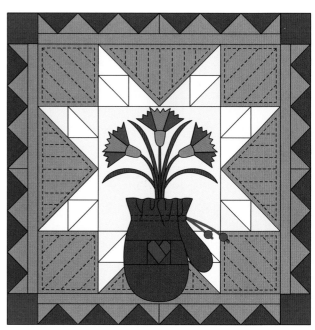

January Carnations
Placement Diagram
15" x 15"

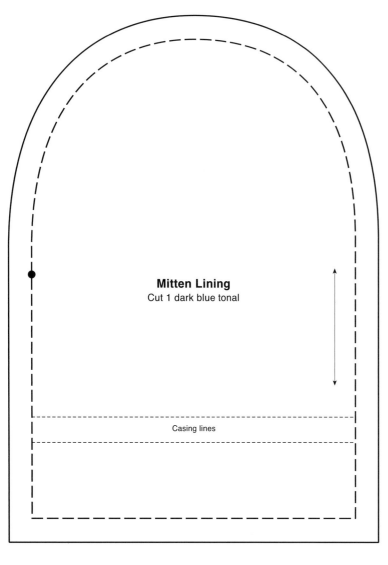

Mitten Lining
Cut 1 dark blue tonal

Casing lines

K
Cut 2 dark
blue tonal
(reverse 1)

red print

red print

Heart Paper-Piecing Pattern
Make 1 copy
Use dark blue tonal for all
unmarked pieces.

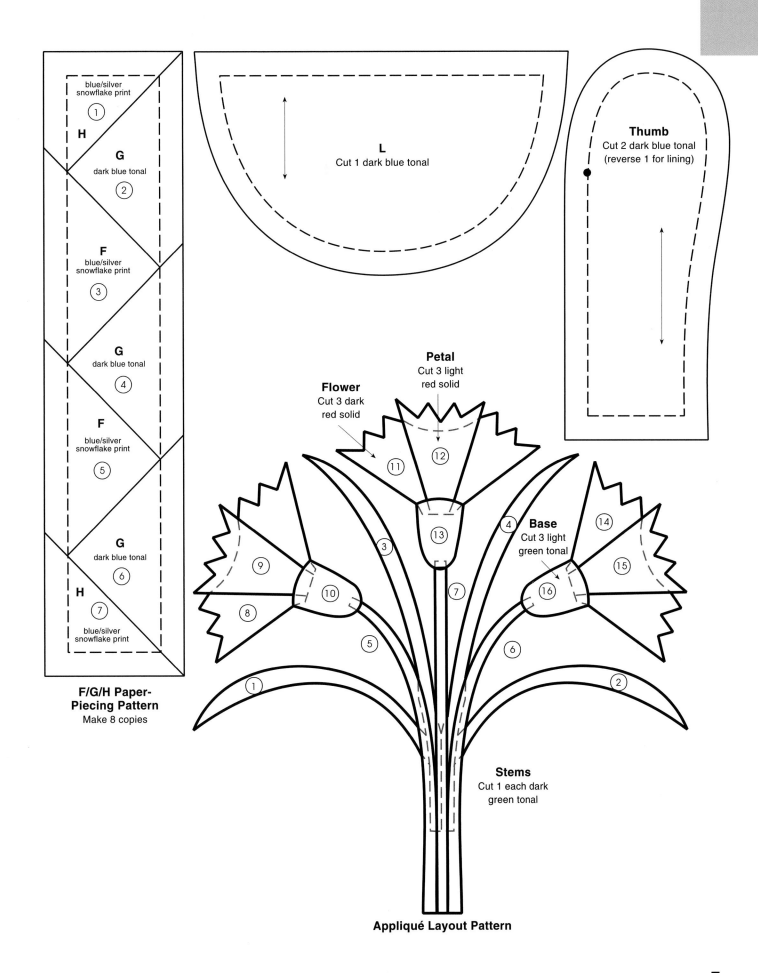

F/G/H Paper-Piecing Pattern
Make 8 copies

blue/silver snowflake print 1
H
G dark blue tonal 2
F blue/silver snowflake print 3
G dark blue tonal 4
F blue/silver snowflake print 5
G dark blue tonal 6
H 7
blue/silver snowflake print

L
Cut 1 dark blue tonal

Thumb
Cut 2 dark blue tonal
(reverse 1 for lining)

Petal
Cut 3 light
red solid

Flower
Cut 3 dark
red solid

Base
Cut 3 light
green tonal

Stems
Cut 1 each dark
green tonal

Appliqué Layout Pattern

February Vine & Buds Heart Wreath

Use a flowering heart shape to show your love for your Valentine.

PROJECT SPECIFICATIONS
Skill Level: Intermediate
Project Size: 15" x 15"
Block Size: 2" x 2"
Number of Blocks: 4

MATERIALS
- Scraps violet and red prints and red stripe
- Fat quarter cream print
- ⅛ yard each red tonal and red dot
- ¼ yard plum print
- ¼ yard cream heart print
- ⅓ yard medium taupe tonal
- Backing 20" x 20"
- Thin batting 20" x 20"
- All-purpose thread to match fabrics
- Contrasting quilting thread
- ⅛ yard fusible web
- ⅜" bias bar
- Erasable marker or pencil
- Basic sewing tools and supplies

Instructions
1. Make four copies of the Log Cabin paper-piecing pattern. Trim each pattern just beyond the outer solid line. Cut pieces referring to Basic Paper Piecing on page 62.

2. Prepare all appliqué pieces referring to Basic Appliqué on page 60.

Log Cabin
2" x 2" Block

3. Cut one 10¾" x 10¾" A square cream print.

4. Cut two ⅞" x 10¾" B strips and two ⅞" x 11½" C strips red tonal.

5. Cut four 2¼" x 14" D strips cream heart print.

6. Cut four 2¼" x 12" F strips cream heart print.

7. Cut eight 2" x 4¾" H rectangles cream heart print.

8. Cut two 1¾" x 14" E strips red dot.

9. Cut two 1¼" x 12" G strips red dot.

10. Cut and prepare two 13" lengths of ⅜"-wide finished bias trim from medium taupe tonal referring to steps 2 and 3 of Completing the Quilt of the November Oak & Pod Blossom Wreath on pages 50 and 52.

 HOUSE OF WHITE BIRCHES, BERNE, INDIANA 46711 WHITEBIRCHES.COM

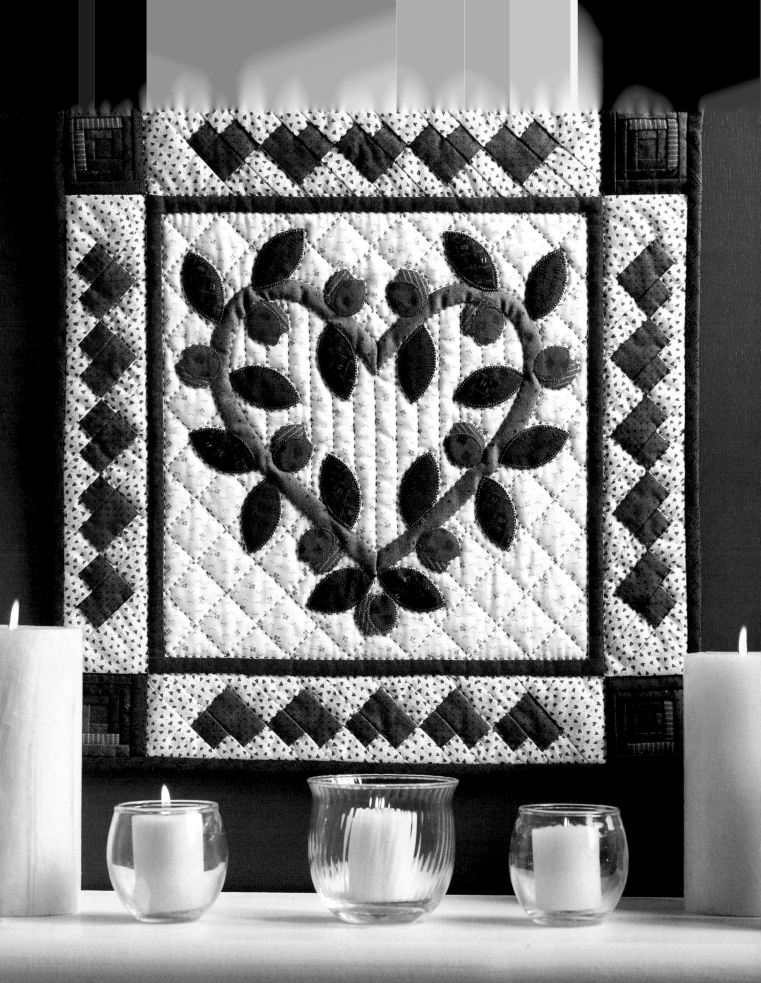

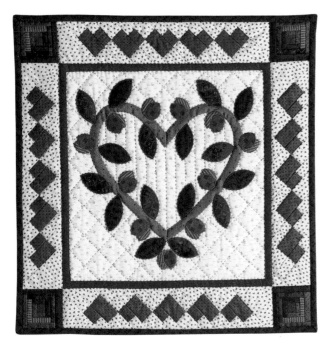

3. Arrange and fuse the bud and leaf shapes on the appliquéd heart shape using the pattern as a guide for placement.

4. Machine-appliqué pieces in place to complete the center panel referring to Basic Appliqué on page 60.

Completing the Heart Border

1. Sew an E strip between two D strips with right sides together along the length to make a D-E strip set; press seams toward E. Repeat to make two D-E strip sets.

2. Subcut the D-E strip sets into (20) 1¼" D-E units as shown in Figure 3.

Figure 3

3. Sew a G strip between two F strips with right sides together along the length to make an F-G strip set; press seams toward G. Repeat to make two F-G strip sets.

Figure 4 **Figure 5**

4. Subcut the F-G strip sets into (20) 1" F-G units as shown in Figure 4.

5. Sew a D-E unit to an F-G unit to make a heart unit, aligning one seam of the E and G pieces as shown in Figure 5; press seam toward the F-G unit. Repeat to make 20 heart units.

6. Join five heart units as shown in Figure 6 to make a border unit; press seams in one direction. Repeat to make four border units.

Figure 6

11. Cut ¾"-wide strips violet print, red dot, red stripe and plum print for Log Cabin strips.

12. Cut four 1" x 1" squares red tonal for Log Cabin centers.

13. Cut two 2¼" by fabric width strips plum print for binding.

Completing the Center

1. Fold and crease the A square to mark the horizontal and vertical centers. Using an erasable marker or pencil, trace the heart appliqué shape onto the A square using the pattern given.

2. Position and baste one length of ⅜"-wide finished bias trim on one half of the marked A square as shown in Figure 1; repeat with the second length, folding and mitering corners in the center where ends meet as shown in Figure 2. Hand-stitch in place.

Figure 1 **Figure 2**

7. Sew an H rectangle to each end of each border unit as shown in Figure 7; press seams toward H.

Figure 7

8. Align the ⅝" line of a see-through ruler over each border unit along the top heart points and trim as shown in Figure 8.

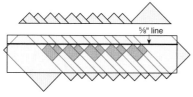

Figure 8

9. Measure 2½" from cut edge and trim each border strip as shown in Figure 9.

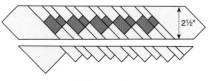

Figure 9

10. Find the center of each border strip and measure 5¾" on each side as shown in Figure 10; trim to make an 11½" strip, again referring to Figure 10.

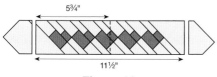

Figure 10

Making Paper-Pieced Blocks

1. Complete four paper-pieced Log Cabin blocks referring to the pattern for color and number order and Basic Paper Piecing on page 62.

Completing the Quilt

1. Sew a B strip to opposite sides and C strips to the top and bottom of the A center; press seams toward B and C strips.

2. Sew a border strip to opposite sides of the pieced center referring to the Placement Diagram for positioning of strips; press seams toward B strips.

3. Sew a Log Cabin block to each end of each remaining border strip as shown in Figure 11; press seams toward the border strips.

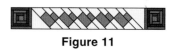

Figure 11

4. Sew the block/border strips to the top and bottom of the pieced center to complete the top referring to the Placement Diagram for positioning of strips; press seams toward C strips.

5. Refer to Completing Your Quilt on page 64 and to the Placement Diagram for quilting suggestions to finish your quilt. ■

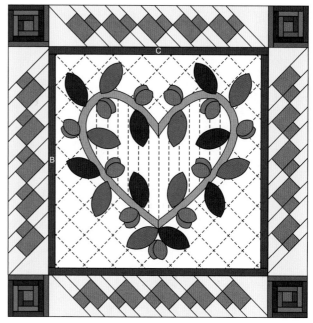

February Vine & Buds Heart Wreath
Placement Diagram
15" x 15"

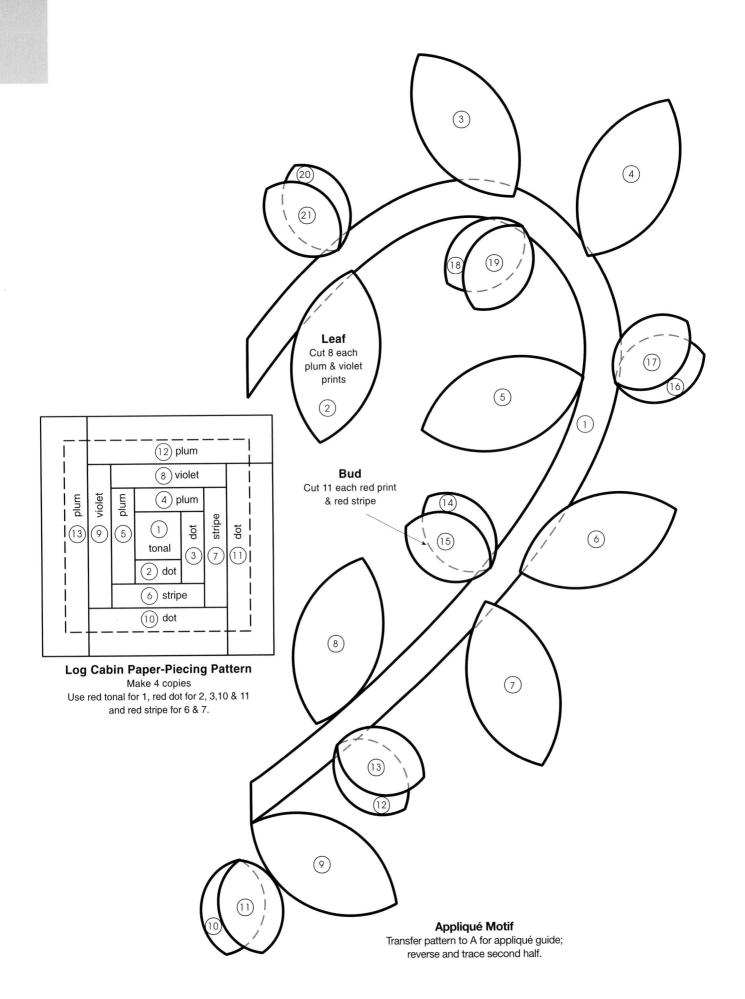

Leaf
Cut 8 each
plum & violet
prints

Bud
Cut 11 each red print
& red stripe

Log Cabin Paper-Piecing Pattern
Make 4 copies
Use red tonal for 1, red dot for 2, 3,10 & 11
and red stripe for 6 & 7.

12 plum
8 violet
4 plum
plum | violet | plum | 1 tonal | dot | stripe | dot
13 | 9 | 5 | | 3 | 7 | 11
2 dot
6 stripe
10 dot

Appliqué Motif
Transfer pattern to A for appliqué guide;
reverse and trace second half.

March Shamrocks & Oxalis

Create a pieced shamrock and add some appliquéd oxalis flowers to make this pretty March banner.

PROJECT SPECIFICATIONS
Skill Level: Advanced
Project Size: 15" x 15"

MATERIALS
- Scraps bright green dot and salmon and white tonals
- ⅛ yard green check
- ⅛ yard dark green print
- ⅛ yard gold mottled
- ¼ yard medium green dot
- ¼ yard green mottled
- Backing 20" x 20"
- Thin batting 20" x 20"
- All-purpose salmon thread and thread to match fabrics
- Contrasting quilting thread
- Template plastic
- ⅛ yard fusible web
- Erasable marker or pencil
- Basic sewing tools and supplies

Instructions

1. Prepare template for E using pattern given; cut as directed.

2. Prepare all appliqué pieces referring to Basic Appliqué on page 60.

3. Cut three of each of the following from green check: 1¼" x 2½" B, 1¼" x 2½" D, 1¼" x 2" K, 1¼" x 2¼" L, 1¼" x 3¾" M and 1¼" x 2¾" N.

4. Cut two 1" x 1¼" Q pieces green check.

5. Cut three of each of the following from dark green print: 1¼" x 2½" C, 1¼" x 2" F, 1¼" x 3¾" G, 1¼" x 3¾" H and 1¼" x 3¼" I.

6. Cut one 1" x 4¾" R strip dark green print.

7. Cut two 2¼" by fabric width strips green mottled for binding.

8. Cut three each 1¾" x 1¾" A squares and 2" x 2" O squares and two 1" x 4¾" P strips medium green dot.

9. Cut one 4½" x 4½" square medium green dot; cut the square in half on one diagonal to make two S triangles.

10. Cut one 3⅜" x 3⅜" square medium green dot; cut the square in half on one diagonal to make two T triangles.

11. Cut one 2" x 2" U square medium green dot; cut the square in half on one diagonal to make two U triangles.

12. Cut one 1½" x 10½" V strip medium green dot.

13. Cut one 2⅞" x 10½" J strip medium green dot.

14. Cut two 1½" x 12½" W, eight 1½" x 2¼" Z and four 1" x 12½" AA strips medium green dot.

15. Cut two 1" by fabric width Y strips medium green dot.

16. Cut two 1" by fabric width X strips gold mottled.

17. Cut four 2" x 2" BB squares salmon tonal.

Piecing the Shamrock

Note: As seams are stitched, press toward green check or dark green print.

1. To make the left half of the pieced shamrock, sew B to A, ending stitching halfway across A to make a partial seam as shown in Figure 1.

Figure 1 **Figure 2**

2. Sew C to the A-B edge and D to the A-C edge of the stitched unit as shown in Figure 2.

3. Sew F to E and add to the D side of the pieced unit as shown in Figure 3.

Figure 3

4. Add G to the pieced unit; align the rotary ruler with the angle on E and trim G as shown in Figure 4. Add H and then I and repeat trimming as shown in Figure 5.

Figure 4 **Figure 5**

5. Finish the partial B seam between A and G referring to Figure 6 to complete the left half of the pieced shamrock.

Figure 6 **Figure 7**

6. To complete the right half of the pieced shamrock, sew K to ER and add L; trim angle as in step 4 and referring to Figure 7. Add M and trim, again referring to Figure 7.

7. Sew O to N, add to the pieced unit and trim angle to complete the right half of the pieced shamrock as shown in Figure 8.

Figure 8 **Figure 9**

8. Join the two pieced half-units to complete one shamrock unit as shown in Figure 9; repeat to make three units.

9. Sew Q to P; press seam toward Q.

10. Join two shamrock units with the P-Q unit as shown in Figure 10; press seams toward the P-Q unit.

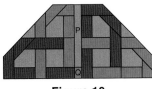

Figure 10

11. Sew R between two S triangles as shown in Figure 11; press seams toward R. Trim R end even with the angle on S as shown in Figure 12 to complete the base unit.

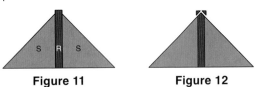

Figure 11 **Figure 12**

12. Sew the base unit to the remaining shamrock unit as shown in Figure 13; press seam toward the base unit.

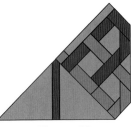

Figure 13

13. Join the shamrock/base unit and the joined shamrock units as shown in Figure 14; press seams toward the base unit.

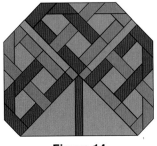

Figure 14

14. Sew U to the bottom corners and T to the top corners of the pieced unit to complete the shamrock center as shown in Figure 15; press seams toward U and T.

Figure 15

Making Checkerboard Borders

1. Sew a Y strip to an X strip with right sides together along the length; press seams toward the X strip. Repeat to make two strip sets.

2. Subcut the strip sets into (68) 1" X-Y units as shown in Figure 16.

Figure 16

3. Join 17 X-Y units, alternating positioning of X and Y pieces to make a side strip as shown in Figure 17; press seams in one direction. Repeat to make four side strips.

Figure 17

4. Sew Z to each end of each side strip; press seams toward Z.

5. Sew AA to one long side of each Z/side strip to complete the border strips as shown in Figure 18; press seams toward AA.

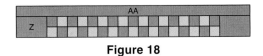

Figure 18

Completing the Quilt

1. Sew J to the bottom and V to the top of the shamrock center referring to the Placement Diagram; press seams toward V and J.

2. Sew W to opposite sides of the shamrock center; press seams toward W.

3. Sew a border strip to the W sides of the pieced center; press seams toward W.

4. Sew a BB square to each end of the remaining border strips; press seams toward the border strips.

5. Sew a BB/border strip to the remaining sides of the pieced center; press seams toward the strip.

6. Arrange and fuse one flower motif in numerical order on the R/J area and two flower motifs on each side of the center referring to the Placement Diagram for positioning and Basic Appliqué on page 60.

7. Add a decorative blanket stitch around the green star in each blossom using salmon thread referring to the close-up photo.

8. Refer to Completing Your Quilt on page 64 and the Placement Diagram for quilting suggestions. Use the quilting design given in the T corners of the shamrock center, again referring to the Placement Diagram for positioning, to finish the quilt. ◼

E
Cut 6 medium green dot
(reverse 3 for ER)

Quilting Design

March Shamrock & Oxalis
Placement Diagram
15" x 15"

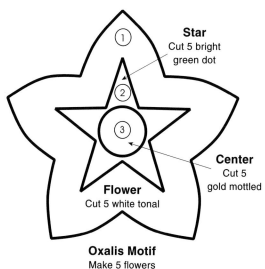

Star
Cut 5 bright green dot

Center
Cut 5 gold mottled

Flower
Cut 5 white tonal

Oxalis Motif
Make 5 flowers

April Spring Breeze Tulips

Make this cheerful April banner using paper-pieced Tulip and Heart blocks in the borders.

PROJECT SPECIFICATIONS
Skill Level: Intermediate
Project Size: 15" x 15"
Block Sizes: 2¾" x 2¾" and
 Approximately 2" x 2"
Number of Blocks: 4 and 17

MATERIALS
- Scraps red tonal, coral batik and cream print
- Fat eighth lime green print
- Fat eighth pink mottled
- Fat eighth yellow tonal
- ¼ yard yellow print
- Backing 20" x 20"
- Thin batting 20" x 20"
- All-purpose thread to match fabrics
- Contrasting quilting thread
- Basic sewing tools and supplies

Heart
2¾" x 2¾" Block
Make 4

Tulip
Approximately 2" x 2" Block
Make 12

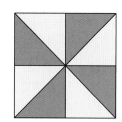

Pinwheel
2" x 2" Block
Make 5

Instructions

1. Make copies of the Tulip and Heart paper-piecing patterns as directed; cut pieces referring to Basic Paper Piecing on page 62.

2. Cut one 6¼" x 8" rectangle each coral batik (H) and yellow tonal (I).

3. Cut four 2½" x 2½" A squares yellow tonal.

4. Cut two 1⅛" x 6½" B strips and two 1⅛" x 7¾" C strips yellow tonal.

5. Cut two 1" x 7¾" D strips and two 1" x 8¾" E strips lime green print.

6. Cut four 4" x 4" squares yellow print; cut each square on both diagonals to make 16 F triangles.

7. Cut eight 2⅜" x 2⅜" squares yellow print; cut each square in half on one diagonal to make 16 G triangles.

8. Cut two 1⅛" x 14¼" J strips and two 1⅛" x 15½" K strips yellow print.

9. Cut two 2¼" by fabric width strips yellow print for binding.

Completing the Pinwheel Blocks

1. Prepare one copy of the AA pattern given.

2. Layer the H and I rectangles with right sides together; pin the AA paper pattern to the layered pieces.

3. With slightly shortened machine stitches, stitch on all dashed stitching lines in the direction indicated by the arrows.

4. Cut squares apart on all vertical and horizontal solid lines; divide into triangles by cutting on diagonal solid (arrow) lines to make H-I units as shown in Figure 1.

Figure 1

5. Press each H-I unit open with seam toward H; remove paper by tearing on stitching perforations.

6. Join four H-I units to complete one Pinwheel block as shown in Figure 2; repeat to make five blocks.

Figure 2 **Figure 3**

7. Release stitches within the seam allowance to press all seams toward H as shown in Figure 3.

Completing the Paper-Pieced Blocks

1. Complete 12 paper-pieced Tulip blocks referring to Basic Paper Piecing on page 62.

2. Complete four paper-pieced Heart blocks referring to Basic Paper Piecing on page 62.

Completing the Quilt

1. Sew an A square between two Pinwheel blocks to make a block row; press seams toward A. Repeat to make two block rows.

2. Sew a Pinwheel block between two A squares to make the center row; press seams toward A.

3. Sew the center row between the two block rows to complete the pieced center; press seams toward the center row.

4. Sew B strips to the top and bottom and C strips to opposite sides of the pieced center; press seams toward B and C strips.

5. Sew D strips to the top and bottom and E strips to opposite sides of the pieced center; press seams toward D and E strips.

6. To make one side strip, sew G to a Tulip block to F to make a G-F unit as shown in Figure 4; press seams toward G and F. Repeat to make two G-F units, again referring to Figure 4.

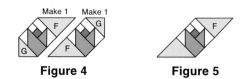

Figure 4 **Figure 5**

7. Sew F to opposite sides of a Tulip block to make an F unit referring to Figure 5; press seams toward F.

Continued on page 57

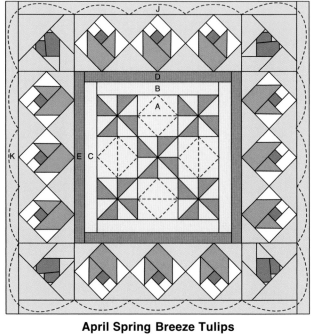

April Spring Breeze Tulips
Placement Diagram
15" x 15"

HOUSE OF WHITE BIRCHES, BERNE, INDIANA 46711 WHITEBIRCHES.COM

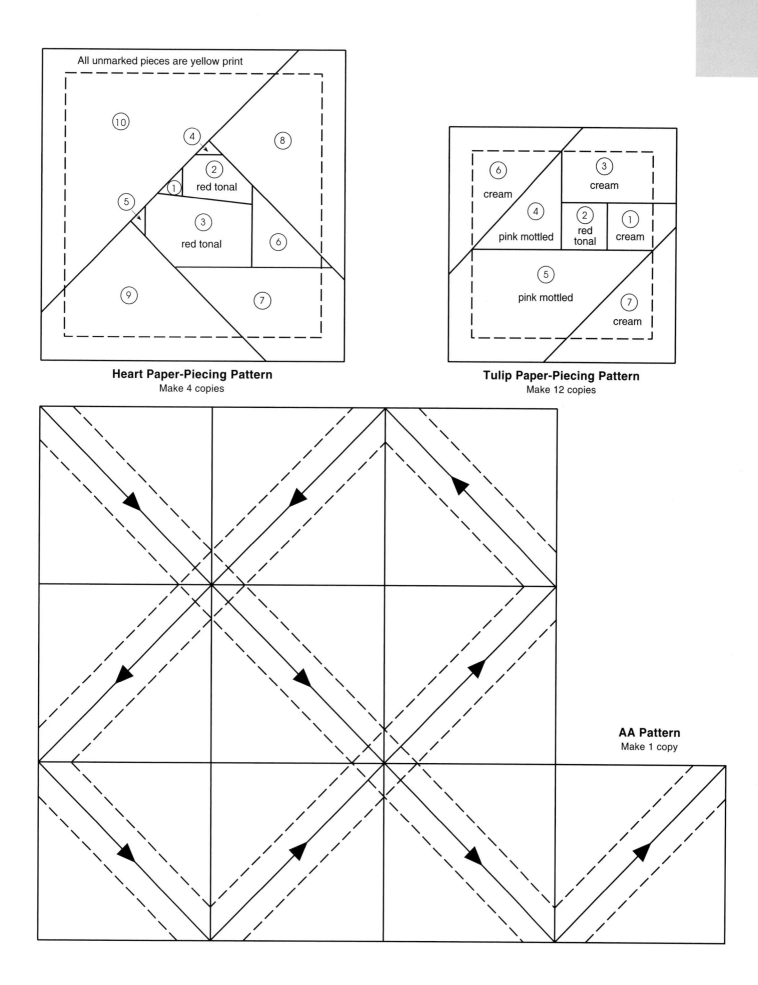

All unmarked pieces are yellow print

⑩ ④ ⑧
②
red tonal
① ⑤
③
red tonal
⑥
⑨ ⑦

Heart Paper-Piecing Pattern
Make 4 copies

⑥
cream
③
cream
④
pink mottled
② red tonal
① cream
⑤
pink mottled
⑦
cream

Tulip Paper-Piecing Pattern
Make 12 copies

AA Pattern
Make 1 copy

May Basket & Mums

Make a fabric May basket filled with pretty pink mums.

PROJECT SPECIFICATIONS
Skill Level: Intermediate
Project Size: 15" x 15"

MATERIALS
- Scraps green print, pink tonal and gold mottled
- ¼ yard light plum tonal
- ⅜ yard brown mottled
- ½ yard dark plum tonal
- Backing 20" x 20"
- Thin batting 20" x 20"
- All-purpose thread to match fabrics
- Contrasting quilting thread
- Template plastic
- 4"-square gridded rotary ruler
- ⅛ yard fusible web
- Basic sewing tools and supplies

Instructions

1. Prepare templates using patterns given; cut as directed on each piece.

2. Prepare all appliqué pieces referring to Basic Appliqué on page 60.

3. Cut (19) 2½" x 2½" A squares each light and dark plum tonals.

4. Cut two ⅞" x 8½" F strips and two ⅞" x 9¼" G strips dark plum tonal.

5. Cut four 1¾" x 1¾" J squares dark plum tonal.

6. Cut two 7⅛" x 7⅛" H squares brown mottled; cut each square in half on one diagonal to make four H triangles.

7. Cut four 1¾" x 3" I pieces brown mottled.

8. Cut two 2¼" by fabric width strips dark plum tonal for binding.

Completing the Appliquéd Basket
1. Fold E to mark the center as shown in Figure 1.

Figure 1

2. Position and fuse the appliqué shapes to E referring to patterns for placement and Basic Appliqué on page 60.

3. Draw a diagonal line from corner to corner on the wrong side of each light plum A square.

4. Layer a light plum A with a dark plum A with right sides together.

5. Stitch ¼" on each side of the marked line as shown in Figure 2; cut apart on the marked line. Open and press seam toward the dark plum side to complete one A unit; repeat to make 38 A units.

Figure 2 **Figure 3**

6. Use the 4"-square gridded rotary ruler to trim the A units to 1¾" x 1¾" as shown in Figure 3.

7. Select six A units and join with the B triangles

as shown in Figure 4 to complete the A-B unit; press as shown by arrows in Figure 4.

Figure 4

8. Sew a dark plum tonal B triangle to the end of C and CR as shown in Figure 5; press seams toward C and CR.

Figure 5　**Figure 6**

9. Sew the B-C and B-CR units to the A-B unit as shown in Figure 6; press seams toward B-C and B-CR units.

10. Add D to the pieced unit to complete the basket bottom, again referring to Figure 6; press seam toward D.

11. Sew the basket bottom to the appliquéd E triangle to complete the basket appliqué; press seam toward E.

12. Machine-appliqué pieces in place referring to Basic Appliqué on page 60.

Completing the Quilt
1. Sew an F strip to opposite sides and G strips to the remaining sides of the pieced center referring to the Placement Diagram; press seams toward F and G strips.

2. Sew an H triangle to each side of the pieced center; press seams toward F.

3. Join four A units to make an A strip as shown in Figure 7; press seams in one direction. Repeat to make four A strips and four reversed A strips, again referring to Figure 7.

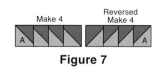

Figure 7

4. Join two A strips with I to make a side strip as shown in Figure 8; press seams toward I. Repeat to make four side strips.

Figure 8

5. Sew a side strip to opposite sides of the pieced center; press seams away from the side strips.

6. Sew J to each end of each remaining side strip; press seams away from J.

7. Sew the J side strips to the remaining sides of the pieced center to complete the top; press seams away from the J side strips.

8. Refer to Completing Your Quilt on page 64 and to the Placement Diagram for quilting suggestions to finish the quilt. ■

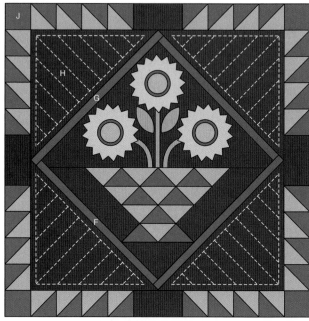

May Basket & Mums
Placement Diagram
15" x 15"

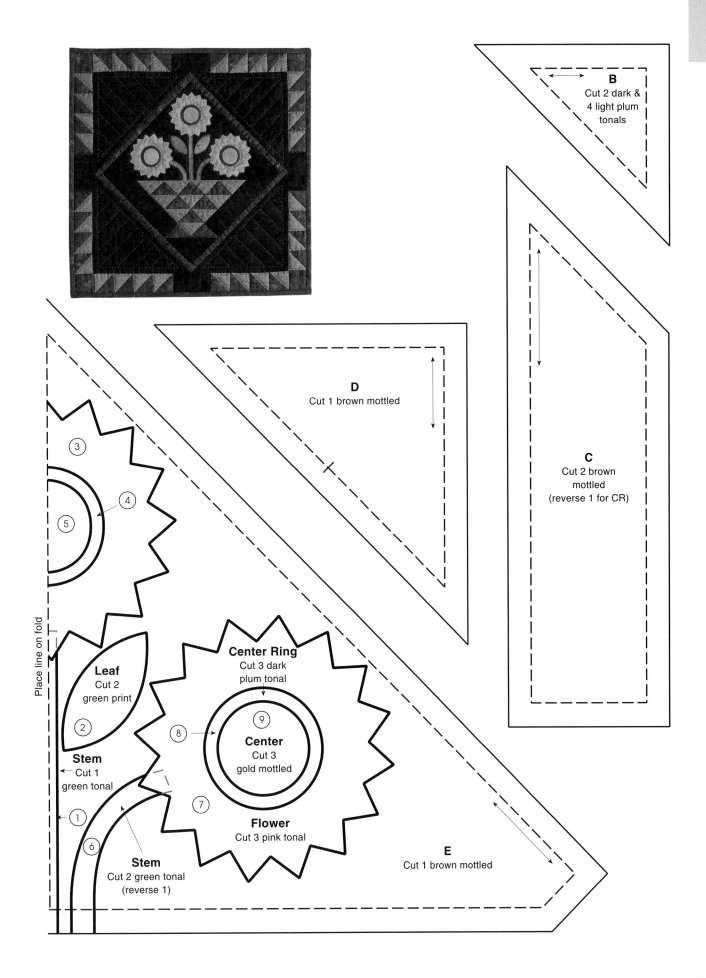

B
Cut 2 dark &
4 light plum
tonals

D
Cut 1 brown mottled

C
Cut 2 brown
mottled
(reverse 1 for CR)

③
④
⑤

Place line on fold

Leaf
Cut 2
green print

②

Center Ring
Cut 3 dark
plum tonal

⑧
⑨

Center
Cut 3
gold mottled

Stem
Cut 1
green tonal

①
⑦
⑥

Flower
Cut 3 pink tonal

Stem
Cut 2 green tonal
(reverse 1)

E
Cut 1 brown mottled

June Rose Bouquet

Appliqué rosebuds to a purchased or handmade doily to make a beautiful June fabric bouquet.

PROJECT SPECIFICATIONS
Skill Level: Advanced
Project Size: 15" x 15"

MATERIALS
- Scraps light, medium and dark rose mottleds and medium and dark green and medium and dark blue prints
- Fat quarter pale blue dot
- Fat quarter cream solid
- ⅛ yard light peach tonal
- ¼ yard dark peach solid
- Backing 20" x 20"
- Thin batting 20" x 20"
- All-purpose thread to match fabrics
- Quilting thread
- Clear nylon monofilament
- Template plastic
- 14" x 14" piece paper
- 12" x 12" square lightweight fusible interfacing
- ½ yard fusible web
- ⅛" hole punch and hammer
- Appliqué pressing sheet
- Erasable marker or pencil
- Basic sewing tools and supplies

Instructions
1. Prepare all appliqué pieces referring to Basic Appliqué on page 60.

2. Cut a 12½" x 12½" A square blue dot.

3. Cut four 1¼" x 12½" strips each light peach tonal (B) and dark peach solid (C).

4. Cut eight 1¼" x 1¼" squares each medium blue (D) and dark blue (E) prints.

5. Cut one 14" x 14" square cream solid for doily.

6. Cut five 1¼" x 4" strips each light peach tonal (F) and cream solid (G).

7. Prepare a template for the ⅙ doily wedge using the pattern given.

8. Fold the 14" x 14" piece of paper in quarters; open flat. Trace the ⅙ doily-wedge template onto the paper six times referring to Figure 1 to make the complete doily pattern.

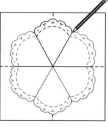
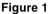

Figure 1

9. Trace the doily shape onto the paper side of the fusible web and fusible interfacing, transferring outer scallop edge, fusible trim line and eyelet holes.

10. Trim the lightweight interfacing at the fusible trim line. Center and fuse to the wrong side of the cream solid square. **Note:** *The interfacing acts as a liner to keep the color of the background square from showing through the doily center.*

HOUSE OF WHITE BIRCHES, BERNE, INDIANA 46711 WHITEBIRCHES.COM

11. Cut away the fusible web in the center of the doily shape at the fusible trim line; roughly cut out around scallops. Center and fuse to the wrong side of the cream solid square along the interfacing edge; cut out on outer scallop line. Do not remove paper backing.

12. Cut two 2¼" by fabric width strips dark peach solid for binding.

Completing the Background

1. Sew a B strip to a C strip with right sides together along the length; press seams toward C strips. Repeat to make four B-C strips.

2. Sew a B-C strip to opposite sides of A; press seams toward the B-C strips.

3. Sew a D square to an E square; press seams toward E. Repeat to make eight D-E units.

4. Join two D-E units to make a corner unit as shown in Figure 2; press seam in one direction. Repeat to make four corner units.

Figure 2 **Figure 3**

5. Sew a corner unit to each end of each remaining B-C strip as shown in Figure 3; press seams toward the corner units.

6. Sew B-C/corner unit strip to the remaining sides of A to complete the pieced top; press seams away from A.

Completing the Doily Appliqué

1. Use a ⅛" hole punch and hammer to cut circles as marked on the paper side of the doily. Remove paper backing.

2. Lightly transfer the rose head and stem placement on each scallop of the doily.

3. Center the doily on the pieced top referring to the Placement Diagram for positioning; fuse in place.

4. Machine-appliqué doily in place referring to Basic Appliqué on page 60.

5. Straight-stitch curved lines in arc shapes and blanket-stitch around eyelet holes on the unfused scallop edges as shown in Photo 1.

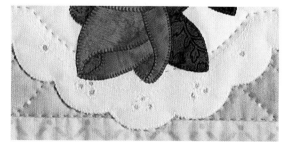

Photo 1

6. Join three F strips with two G strips with right sides together along the 4" sides to make an F-G strip set as shown in Figure 4; press seams toward F strips.

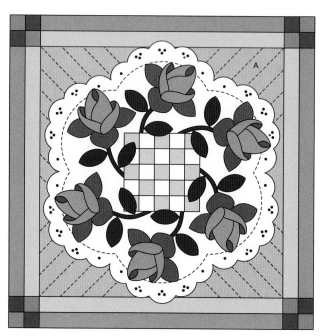

June Rose Bouquet
Placement Diagram
15" x 15"

Figure 4

7. Repeat step 6 with three G strips and two F strips to make a G-F strip set, again referring to Figure 4.

8. Subcut the F-G strip set into three 1¼" F-G units and the G-F strip set into two 1¼" G-F units, again referring to Figure 4.

9. Join the F-G and G-F units to complete the checkerboard unit as shown in Figure 5; press seams in one direction.

Figure 5

10. Press under ¼" all around edge; baste to hold.

11. Crease the pieced top in quarters to mark the centerlines. Center the checkerboard unit on the doily; pin to hold.

12. Using the appliqué pressing sheet, assemble six rose motifs in numerical order, placing pattern under the sheet to help with positioning and fusing shapes as they are placed. *Note: Do not include Leaf 13 in this step. It will be added later.*

13. Arrange and fuse a rose motif in each scallop, tucking stem ends under the checkerboard unit referring to Photo 2.

Photo 2

14. Machine-appliqué the checkerboard unit in place referring to Basic Appliqué on page 60.

15. Arrange the remaining leaf shapes on rose motifs, overlapping the checkerboard unit referring to the Placement Diagram for positioning; fuse shapes in place.

16. Machine-appliqué the rose and leaf motifs in place referring to Basic Appliqué on page 60.

17. Refer to Completing Your Quilt on page 64 and the Placement Diagram for quilting suggestions to finish the quilt. ■

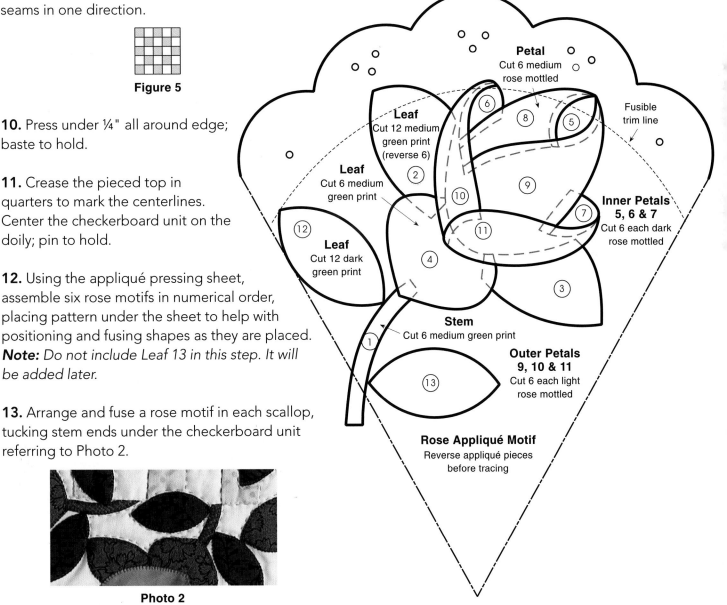

Petal
Cut 6 medium
rose mottled

Fusible
trim line

Leaf
Cut 12 medium
green print
(reverse 6)

Leaf
Cut 6 medium
green print

Inner Petals
5, 6 & 7
Cut 6 each dark
rose mottled

Leaf
Cut 12 dark
green print

Stem
Cut 6 medium green print

Outer Petals
9, 10 & 11
Cut 6 each light
rose mottled

Rose Appliqué Motif
Reverse appliqué pieces
before tracing

⅙ Doily Appliqué Pattern

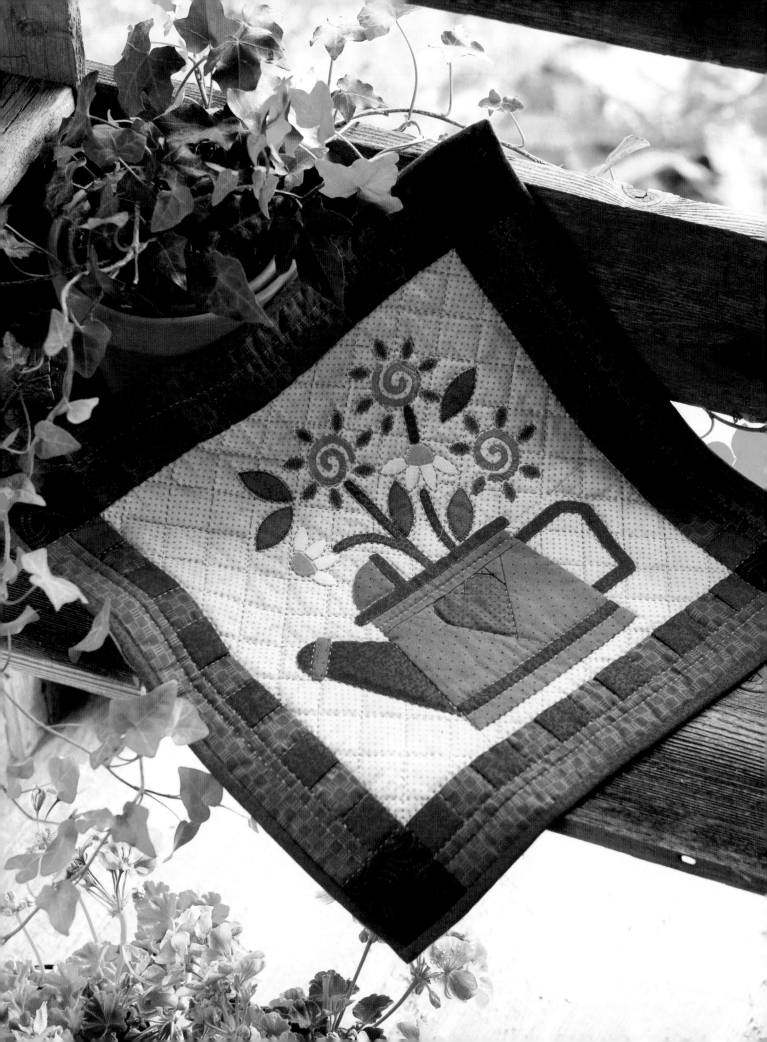

July Watering-Can Posies

Hand-picked fabric flowers from your scrap bag fill this paper-pieced watering can.

PROJECT SPECIFICATIONS
Skill Level: Intermediate
Project Size: 15" x 15"

MATERIALS
- 4 (2½" x 2½") H squares navy tonal
- Scraps rose, green, cream, gold and coral tonals, solids or dots
- ⅛ yard blue dot
- ¼ yard medium blue print
- ¼ yard cream dot
- ¼ yard red tonal
- Backing 20" x 20"
- Thin batting 20" x 20"
- All-purpose thread to match fabrics
- Contrasting quilting thread
- Template plastic
- ⅛ yard fusible web
- Erasable marker or pencil
- Basic sewing tools and supplies

Instructions
1. Copy the section A paper-piecing pattern as directed; cut pieces referring to Basic Paper Piecing on page 62.

2. Prepare templates for pieces B and C using patterns given; cut as directed on the pieces.

3. Prepare all appliqué pieces referring to Basic Appliqué on page 60.

4. Cut one 6⅞" x 11½" D rectangle cream dot.

5. Cut one 1½" by fabric width strip each red tonal (E) and medium blue print (F).

6. Cut four 1½" x 11½" G strips medium blue print.

7. Cut two 2¼" by fabric width strips red tonal for binding.

Completing the Center
1. Complete section A paper-pieced watering can referring to the instructions on page 62.

2. Position and fuse the appliqué shapes to the B and C pieces referring to patterns for placement and Basic Appliqué on page 60. **Note:** *Do not fuse the top of the watering-can spout to the seam allowance area of B.*

3. Sew the fused B and C pieces to the A section as shown in Figure 1; press seams toward the A section. Remove paper pattern. **Note:** *The unfused top of the watering-can spout will extend above the stitched unit.*

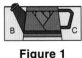

Figure 1

4. Fold D and crease to mark the center as shown in Figure 2.

Figure 2

5. Trace appliqué design on D and fuse pieces in place referring to Basic Appliqué on page 60.

6. Sew the fused D piece to the A-B-C section; press seams away from D. *Note: Be careful not to catch the edge of the can trim piece in the seam when joining sections.*

7. Fuse top section of spout in place on D.

8. Machine-appliqué pieces in place referring to Basic Appliqué on page 60.

Completing the Quilt

1. Sew an E strip to an F strip with right sides together along the length; press seam toward E.

2. Subcut the E-F strip set into (24) 1½" E-F units as shown in Figure 3.

Figure 3

3. Join six E-F units as shown in Figure 4; press seams toward E. Remove the F piece from one end to complete an E-F strip, again referring to Figure 4; repeat to make four E-F strips.

Figure 4

4. Sew a G strip to each E-F strip to complete the side strips as shown in Figure 5; press seams toward G strips.

Figure 5

5. Sew a side strip to opposite sides of the appliquéd center; press seams toward the side strips.

6. Sew an H square to each end of each of the remaining side strips; press seams toward H. Sew the H/side strips to the remaining sides of the completed center to complete the top; press seams toward the H/side strips.

7. Refer to Completing Your Quilt on page 64 and to the Placement Diagram for quilting suggestions to finish the quilt. ■

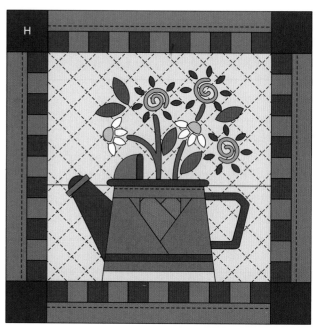

July Watering-Can Posies
Placement Diagram
15" x 15"

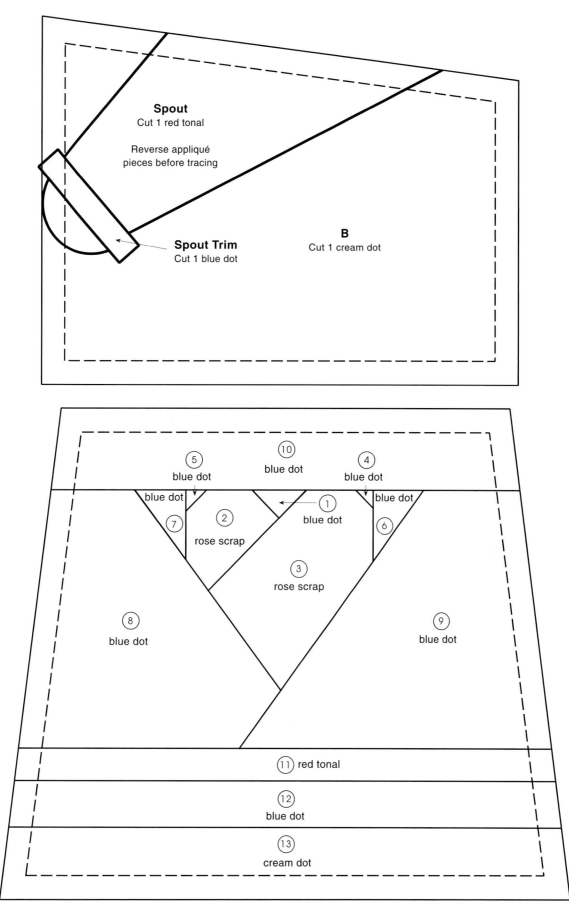

Spout
Cut 1 red tonal

Reverse appliqué
pieces before tracing

Spout Trim
Cut 1 blue dot

B
Cut 1 cream dot

5
blue dot

10
blue dot

4
blue dot

blue dot

1
blue dot

7

2
rose scrap

6
blue dot

3
rose scrap

8
blue dot

9
blue dot

11 red tonal

12
blue dot

13
cream dot

Section A Paper-Piecing Pattern
Make 1 copy

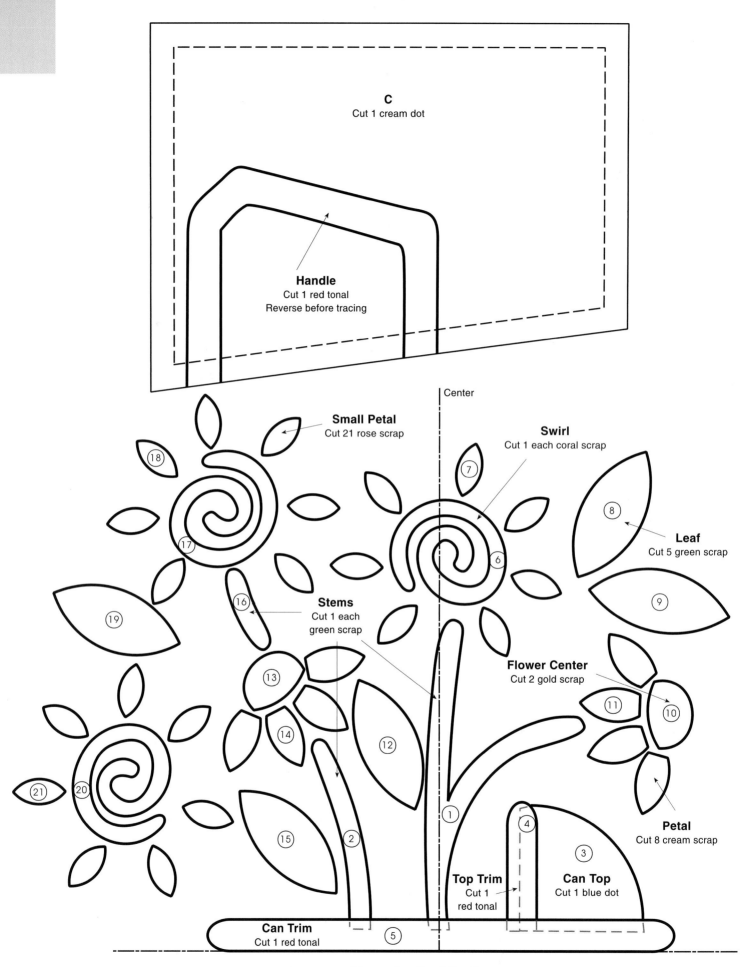

C
Cut 1 cream dot

Handle
Cut 1 red tonal
Reverse before tracing

Center

Small Petal
Cut 21 rose scrap

Swirl
Cut 1 each coral scrap

Leaf
Cut 5 green scrap

Stems
Cut 1 each
green scrap

Flower Center
Cut 2 gold scrap

Petal
Cut 8 cream scrap

Top Trim
Cut 1
red tonal

Can Top
Cut 1 blue dot

Can Trim
Cut 1 red tonal

Flower Appliqué Motif
Cut as directed
Pattern given in reverse for fusible appliqué

August Sunflower

A pieced-and-appliquéd sunflower motif makes the perfect late-summer accent.

PROJECT SPECIFICATIONS
Skill Level: Intermediate
Project Size: 15" x 15"
Block Size: 7¾" x 7¾"
Number of Blocks: 1

MATERIALS
- Scraps 8 different gold prints
- Scraps 2 different green prints
- Scraps deep gold print and cream tonal
- ⅛ yard dark green tonal
- ⅛ yard rust mottled
- ⅛ yard brown dot
- ¼ yard pale gold dot
- ¼ yard gold print
- Backing 20" x 20"
- Thin batting 20" x 20"
- All-purpose thread to match fabrics
- Contrasting quilting thread
- ⅛ yard fusible web
- Basic sewing tools and supplies

Instructions

1. Prepare all appliqué pieces referring to Basic Appliqué on page 60.

2. Cut one 4¾" x 4¾" A square and one 2¾" x 2¾" M square deep gold print. Cut the M square on both diagonals to make four M triangles.

3. Cut four 1¾" x 1¾" B squares rust mottled; mark a diagonal line from corner to corner on the wrong side of each square.

4. Cut one 3" x 3" H square rust mottled; cut the square on both diagonals to make four H triangles.

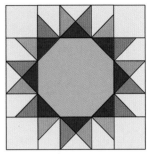

Sunflower Star
7¾" x 7¾" Block

5. Cut six 1" x 4½" J strips and two 1⅛" x 4½" K strips rust mottled.

6. Cut one 3" x 3" C square, four 1¾" x 2¼" D rectangles and four 2¼" x 2¼" E squares pale gold dot; cut the C square on both diagonals to make four C triangles.

7. Arrange the gold scraps in desired order for sunflower points (fabrics will be repeated across each flower half); assign numbers 1–8. **Note:** *Numbers 1, 2, 5 and 6 will be in the quarter-square triangle positions and numbers 3, 4, 7 and 8 will be in the corner positions.*

8. Cut one 3" x 3" G square from each 1, 2, 5 and 6 gold scrap and two 1¾" x 1¾" F squares from each 3, 4, 7 and 8 gold scrap; cut each G square on both diagonals to make G triangles. You will need two G triangles of each fabric.

9. Cut seven 1" x 4½" I strips cream tonal.

10. Cut eight ¾" x 8¼" L strips dark green tonal.

11. Cut two 6⅜" x 6⅜" squares pale gold dot; cut each square in half on one diagonal to make four N triangles.

12. Cut two ⅞" x 13" O strips and two ⅞" x 13¾" P strips brown dot.

13. Cut two 1⅜" x 13¾" Q strips and two 1⅜" x 15½" R strips gold print.

14. Cut two 2¼" by fabric width strips gold print for binding.

Completing the Center Block

1. Referring to Figure 1, pin a B square to each corner of A; stitch on the marked line. Trim the seam to ¼" and press B to the right side to complete the A-B unit.

Figure 1 **Figure 2**

2. Sew H to G and C to G as shown in Figure 2; press seams toward the darker fabric.

3. Sew the H-G unit to the C-G unit to make an H-G-C unit as shown in Figure 3; repeat to make four H-G-C units. Press seam to one side.

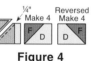

Figure 3 **Figure 4**

4. Mark a diagonal line from corner to corner on the wrong side of each F square. Referring to Figure 4, place an F square on D and stitch on the marked line, trim seam to ¼" and press F to the right side to complete a D-F unit; repeat to make four D-F units.

5. Repeat step 4 to make four reversed D-F units, again referring to Figure 4.

6. Sew a D-F and reversed D-F unit to opposite sides of an H-G-C unit referring to Figure 5 to make a side unit; repeat to make four side units. Press seams toward the H-G-C units.

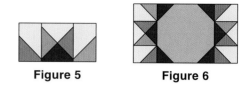

Figure 5 **Figure 6**

7. Sew a side unit to opposite sides of the A-B unit to make the center row as shown in Figure 6; press seams toward the A-B unit.

8. Sew an E square to each end of the remaining side units to make the top and bottom rows referring to Figure 7; press seams toward E.

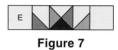

Figure 7

9. Sew the top and bottom rows to the center row to complete the block referring to the block drawing for positioning of rows; press seams toward the center row.

Completing the Quilt

1. Sew an I strip to a J strip; press seams toward J. Continue adding strips in this sequence, adding the extra I strip to the J end to make an I-J unit as shown in Figure 8.

2. Sew a K strip to each end of the I-J unit, again referring to Figure 8; press seams toward the K strips.

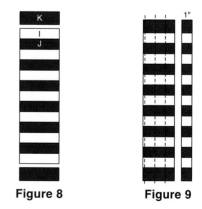

Figure 8 **Figure 9**

3. Subcut the I-J-K unit into four 1" segments as shown in Figure 9.

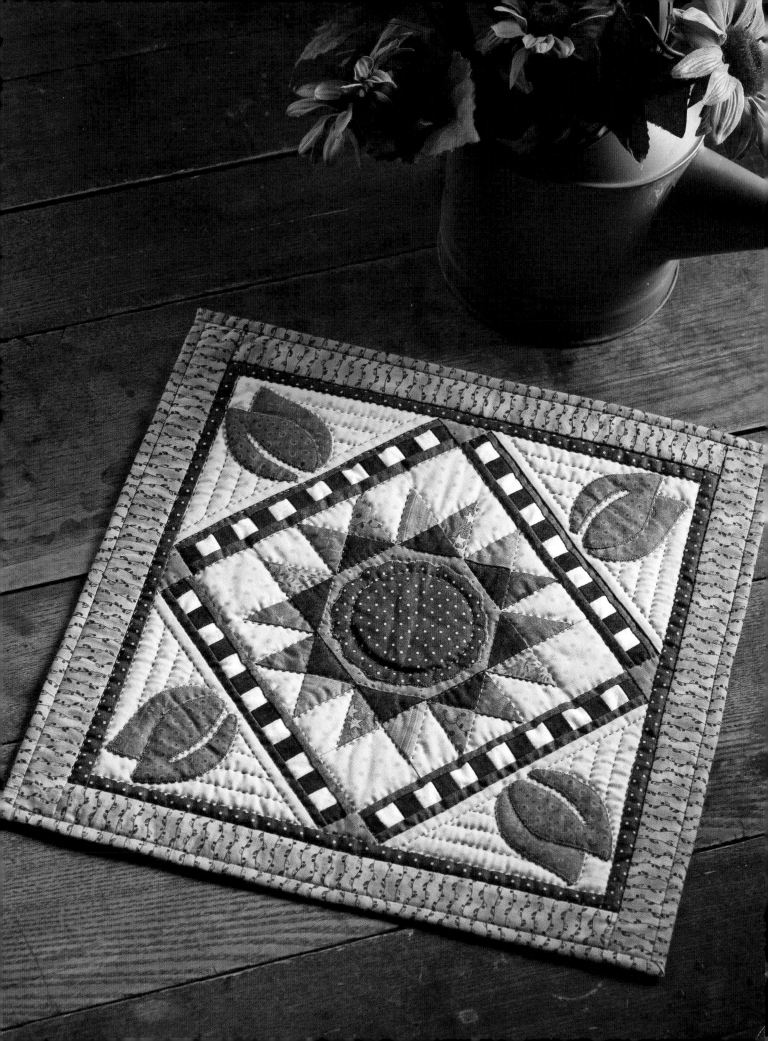

4. Sew an L strip to opposite sides of each I-J-K segment to make four side strips as shown in Figure 10; press seams toward L strips.

Figure 10

5. Sew a side strip to opposite sides of the pieced center block; press seams toward the side strips.

6. Sew an M triangle to each end of each remaining side strip as shown in Figure 11; press seams toward M.

Figure 11

7. Sew the M/side strips to the remaining sides of the pieced center block referring to Figure 12; press seams toward the M/side strips.

Figure 12

8. Sew an N triangle to each side of the pieced section; press seams toward N.

9. Sew an O strip to the top and bottom and P strips to opposite sides of the pieced center; press seams toward the O and P strips.

10. Sew a Q strip to the top and bottom and R strips to opposite sides of the pieced center; press seams toward the Q and R strips.

11. Arrange and apply appliqué shapes to the A-B center and the N triangles referring to Basic Appliqué on page 60 to complete the top.

12. Refer to Completing Your Quilt on page 64 and to the Placement Diagram for suggested quilting to finish the quilt. ■

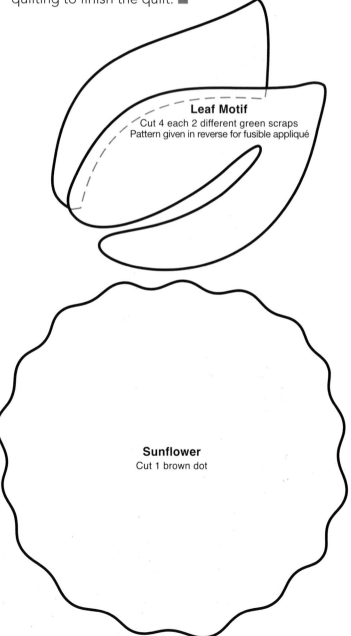

Leaf Motif
Cut 4 each 2 different green scraps
Pattern given in reverse for fusible appliqué

Sunflower
Cut 1 brown dot

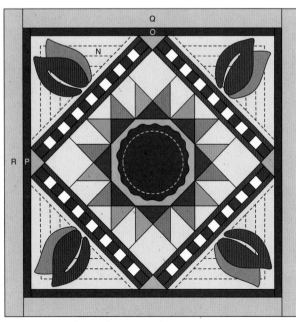

August Sunflower
Placement Diagram
15" x 15"

September Asters

Appliquéd asters weave in and out over a pieced star background and the fabric basket in this autumn banner.

PROJECT SPECIFICATIONS
Skill Level: Intermediate
Project Size: 15" x 15"

MATERIALS
- Scraps gold mottled, black check and dark brown tonal
- ⅛ yard each medium green tonal and green print
- ⅛ yard each plum tonal and purple print
- ⅛ yard multicolor batik
- ⅛ yard each brown dot and light brown tonal
- ⅓ yard cream tonal
- ⅓ yard violet mottled
- Backing 20" x 20"
- Thin batting 20" x 20"
- All-purpose thread to match fabrics
- Contrasting quilting thread
- Template plastic
- ⅛ yard fusible web
- Erasable marker or pencil
- Basic sewing tools and supplies

Instructions
1. Prepare all appliqué pieces referring to Basic Appliqué on page 60.

2. Copy paper-piecing pattern as directed.

3. Cut four 1½" x 1½" A squares and one 1½" x 3½" C rectangle green print.

4. Cut (20) 1½" x 1½" B squares medium green tonal; draw a diagonal line from corner to corner on the wrong side of each square.

5. Cut the following rectangles from cream tonal: four 1½" x 3½" D, two 1½" x 4½" E, four 1½" x 2½" G, two 2½" x 3" H, four 1½" x 2" I, two 1½" x 3" J, two 1¼" x 1½" K, two 2" x 4¼" O, one 2¼" x 12½" P and one 1¼" x 12½" Q.

6. Cut four 1½" x 1½" F squares and four ¾" x ¾" M squares cream tonal. Draw a diagonal line from corner to corner on each M square.

7. Cut four 4¼" x 4¼" squares cream tonal; cut each square on both diagonals to make 16 V triangles.

8. Cut one 1¼" x 10½" L strip brown dot.

9. Cut one 4¼" x 9½" N strip dark brown tonal.

10. Cut six 2¾" x 2¾" squares multicolor batik; cut each square on both diagonals to make 24 T triangles for paper piecing.

11. Cut 12 each multicolor batik R and black check S triangles for paper piecing using pattern and referring to Basic Paper Piecing on page 62.

12. Cut two 3⅞" x 3⅞" squares violet mottled; cut each square in half on one diagonal to make four U triangles.

13. Cut two 2¼" by fabric width strips violet mottled for binding.

Completing the Quilt Center

1. Referring to Figure 1, place B right sides together on one end of E and stitch on the marked line; trim seam allowance to ¼" and press B to the right side to complete a B-E unit. Repeat to make one reversed B-E unit, again referring to Figure 1.

Figure 1

2. Repeat step 1 with B on D, F, G, I and J pieces referring to Figure 2.

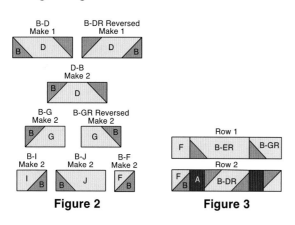

Figure 2 **Figure 3**

3. Arrange pieced units in rows with A and F as shown in Figure 3 to make rows 1 and 2; press seams away from cream tonal pieces and toward A.

4. Join rows 1 and 2 and add H to each end to complete row 1-2 as shown in Figure 4; press seams away from H.

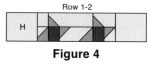

Figure 4

5. Arrange and join pieced units with I and F to make row 3 as shown in Figure 5; press seams away from cream tonal pieces.

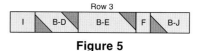

Figure 5

6. Arrange and join pieced units with A to make row 4 as shown in Figure 6; press seams in opposite directions from row 3.

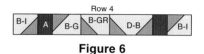

Figure 6

7. Arrange and join pieced units with I and C to complete row 5 as shown in Figure 7; press seams in opposite directions from row 4.

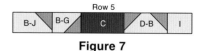

Figure 7

8. Join the rows in numerical order to complete the pieced background as shown in Figure 8; press seams in one direction.

Figure 8

9. Sew P to the row 1-2 edge of the pieced background, referring to Figure 9; press seam toward P.

Figure 9

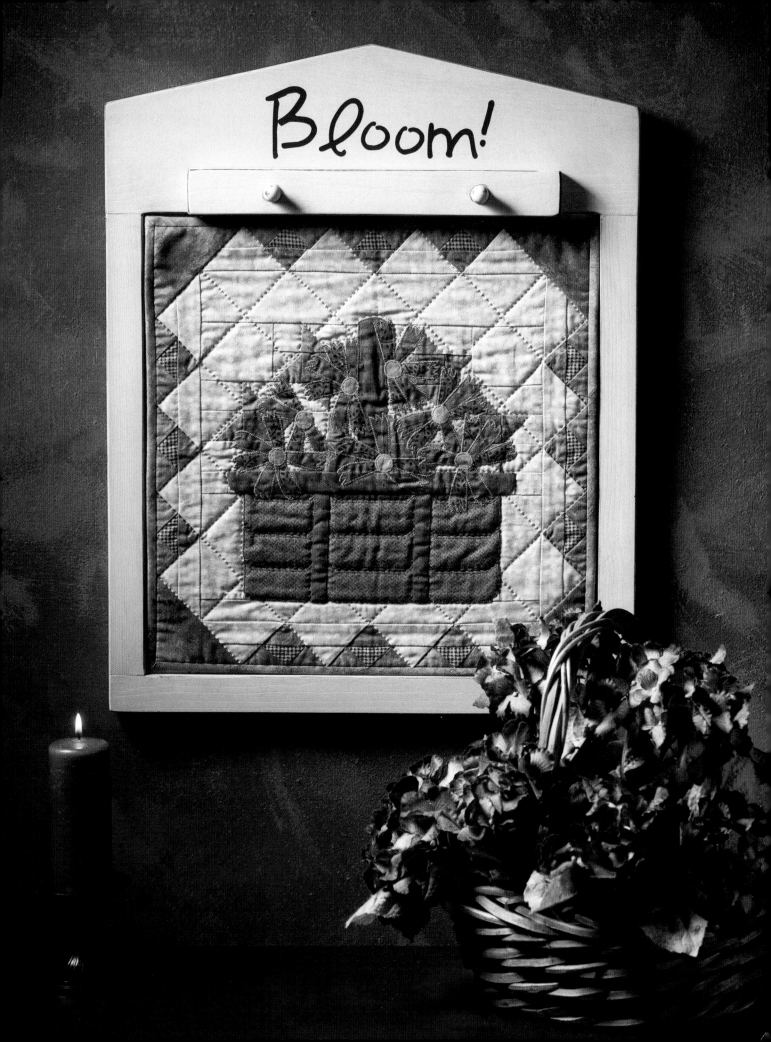

10. Referring to Figure 10 and repeating step 1, sew M to L to complete an L-M unit and to N to complete an M-N unit.

Figure 10

11. Add K to each end of the L-M unit to complete the L-M-K row; press seams away from K.

12. Sew the L-M-K row to the row 5 edge of the pieced background referring to Figure 11; press seam toward the L-M-K row.

Figure 11

13. Mark lines 1½" and 2¾" from the top edge of the M-N unit using the erasable marker or pencil as shown in Figure 12; crease to mark the vertical center.

Figure 12

14. Center a reed shape on each of the marked lines and ¼" above the bottom edge of the M-N unit as shown in Figure 13; fuse in place.

Figure 13

15. Position the ribs on the reed/M-N piece referring to the dashed lines on the reed pattern; fuse in place to complete the basket bottom.

16. Sew O to opposite ends of the M-N unit and add Q to complete the basket bottom unit as shown in Figure 14; press seams toward the M-N unit.

Figure 14

17. Sew the basket bottom to the pieced background to complete the pieced center; press seam toward the L-M-K row.

18. Arrange, fuse and appliqué the basket handle, flower petals and flower centers to the pieced center referring to the appliqué layout pattern and to Basic Appliqué on page 60 to complete the quilt center.

Completing the Quilt

1. Complete 12 paper-pieced triangles using R,

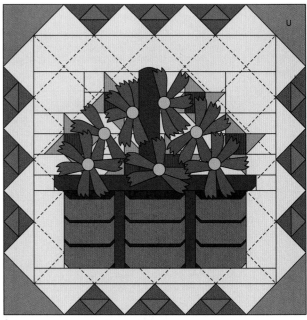

September Asters
Placement Diagram
15" x 15"

S and T triangles and referring to Basic Paper Piecing on page 62.

2. Join three paper-pieced triangles with four V triangles to make a side strip as shown in Figure 15; press seams away from V. Repeat to make four side strips.

Figure 15

3. Sew a side strip to each side of the completed quilt center; press seams toward side strips.

4. Sew a U triangle to each corner to complete the quilt top; press seams toward U.

5. Refer to Completing Your Quilt on page 64 and the Placement Diagram for quilting suggestions to finish the quilt. ■

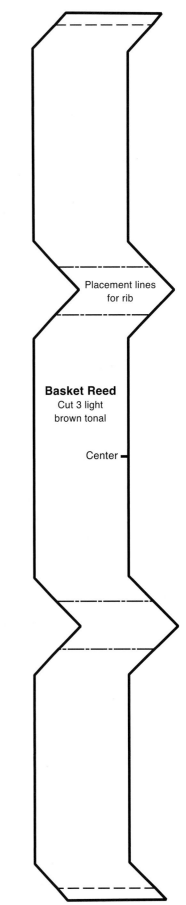

Placement lines for rib

Basket Reed
Cut 3 light brown tonal

Center ◄

Rib
Cut 2 brown dot

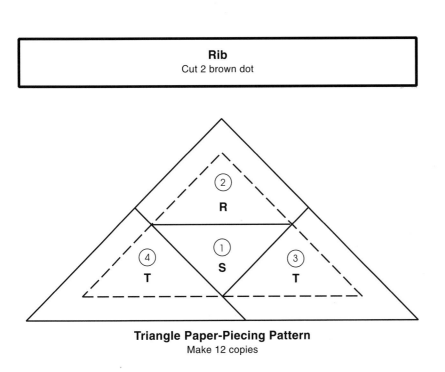

Triangle Paper-Piecing Pattern
Make 12 copies

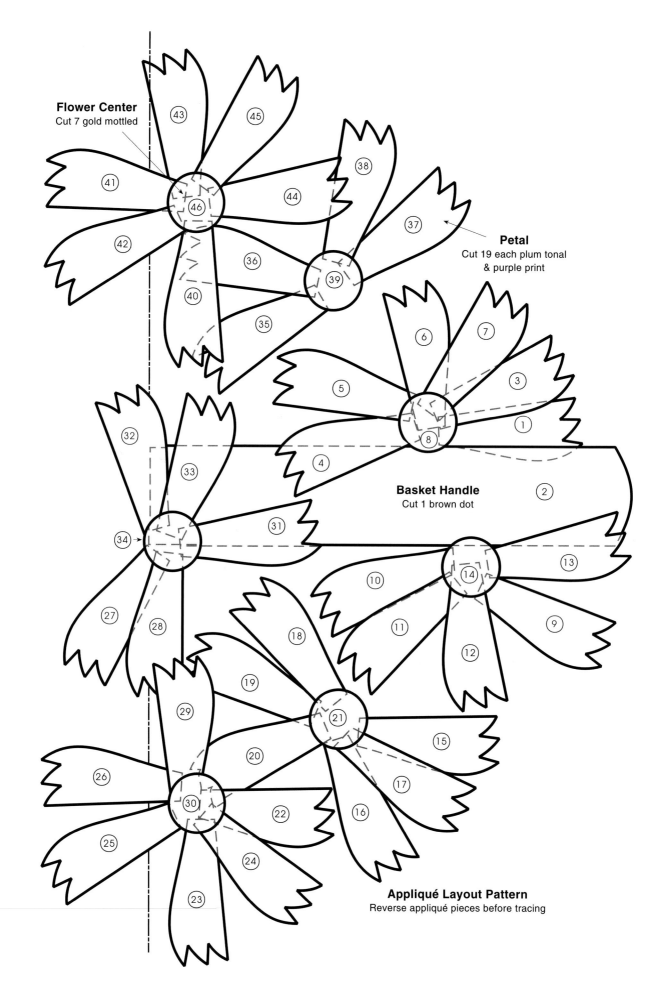

Flower Center
Cut 7 gold mottled

Petal
Cut 19 each plum tonal
& purple print

Basket Handle
Cut 1 brown dot

Appliqué Layout Pattern
Reverse appliqué pieces before tracing

October Thistle Blossoms

Thistles blossom at the end of the growing season and provide a burst of color before winter sets in.

PROJECT SPECIFICATIONS
Skill Level: Advanced
Project Size: 15" x 15"
Block Size: 6" x 6"
Number of Blocks: 4

MATERIALS
- Scraps 4 purples, 2 teals and 10 oranges
- 1 fat eighth orange check
- ⅛ yard each violet solid and green print
- ¼ yard orange tonal
- Backing 20" x 20"
- Thin batting 20" x 20"
- All-purpose thread to match fabrics
- Contrasting quilting thread
- Template plastic
- ⅛ yard fusible web
- Erasable marker or pencil
- Basic sewing tools and supplies

Instructions
1. Prepare all appliqué pieces referring to Basic Appliqué on page 60.

2. Copy paper-piecing patterns as directed with the pattern.

3. Cut pieces for paper-piecing sections using patterns and referring to Basic Paper Piecing on page 62.

4. Cut one ⅞" x 6½" E strip and one ⅞" x 6⅞" F strip from each of the four purple scraps.

Thistle Blossom
6" x 6" Block

5. Cut two 1¼" x 7" G strips from each of the 10 orange scraps.

6. Cut two 2¼" by fabric width strips orange tonal for binding.

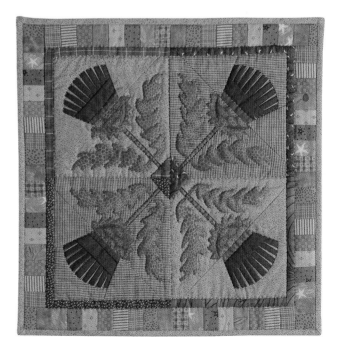

Completing the Blocks

1. Complete one section D paper-pieced unit referring to Basic Paper Piecing on page 62. Repeat to complete two each with orange check and orange tonal backgrounds.

2. Center and arrange one calyx unit on each D section, creating two of each using the two teal scraps and referring to the calyx appliqué layout diagram for positioning. When satisfied with placement, fuse in place.

3. Arrange and fuse a leaf and a reversed leaf on the D paper-pieced units referring to the pattern for positioning.

4. Complete one section A paper-pieced unit referring to Basic Paper Piecing on page 62. Repeat to complete two each with orange check and orange tonal backgrounds.

5. Sew a matching B piece to the curved top edge and matching C and CR pieces to opposite sides of each paper-pieced A unit as shown in Figure 1; press seams toward B, C and CR to complete a thistle unit.

Figure 1

6. Sew a thistle unit to a matching D unit to complete one Thistle Blossom block as shown in Figure 2; press seam toward the thistle unit. Repeat to make four blocks.

Figure 2

Completing the Quilt

1. Sew E to match the base triangle to one thistle side and F to the adjacent side of each pieced block as shown in Figure 3; press seams toward E and F strips.

Figure 3

2. Join two different blocks to make a row referring to the Placement Diagram for positioning; press seam in one direction. Repeat to make two rows.

3. Join the two rows referring to the Placement Diagram to complete the quilt center; press seam in one direction.

4. Join the G strips along the length in a pleasing order to create a G strip set; press seams in one direction. Subcut the strip set into four 1⅝" G units as shown in Figure 4.

Figure 4

5. Sew a G unit to one side of the quilt center, stopping stitching 2" from the end as shown in Figure 5; press seam away from the G unit, leaving unstitched portion unpressed.

Figure 5

6. Position and stitch a second G unit to the adjacent edge of the quilt center as shown in Figure 6, aligning the strip on the quilt corner and letting the strip end extend off the bordered edge. Press seam away from the G unit; trim excess G unit at end.

Figure 6

7. Add the remaining G units to the quilt edges in the same way, keeping the unstitched end of the first G unit out of the way when adding the last G unit.

8. Reposition and complete the remaining unstitched portion of the first G unit as shown in Figure 7; trim excess and press to complete the top.

Figure 7

9. Refer to Completing Your Quilt on page 64 to finish the quilt. ■

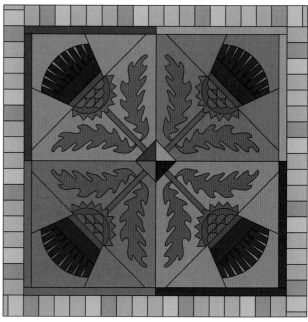

October Thistle Blossoms
Placement Diagram
15" x 15"

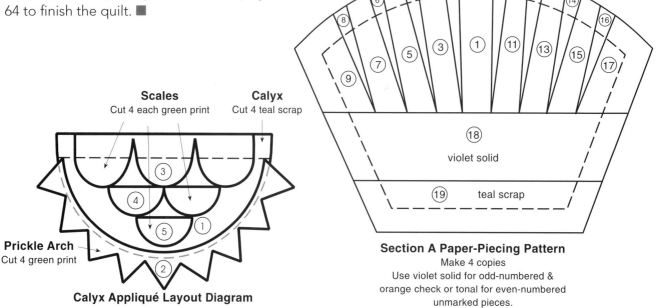

Scales
Cut 4 each green print

Calyx
Cut 4 teal scrap

Prickle Arch
Cut 4 green print

Calyx Appliqué Layout Diagram

Section A Paper-Piecing Pattern
Make 4 copies
Use violet solid for odd-numbered &
orange check or tonal for even-numbered
unmarked pieces.

violet solid

teal scrap

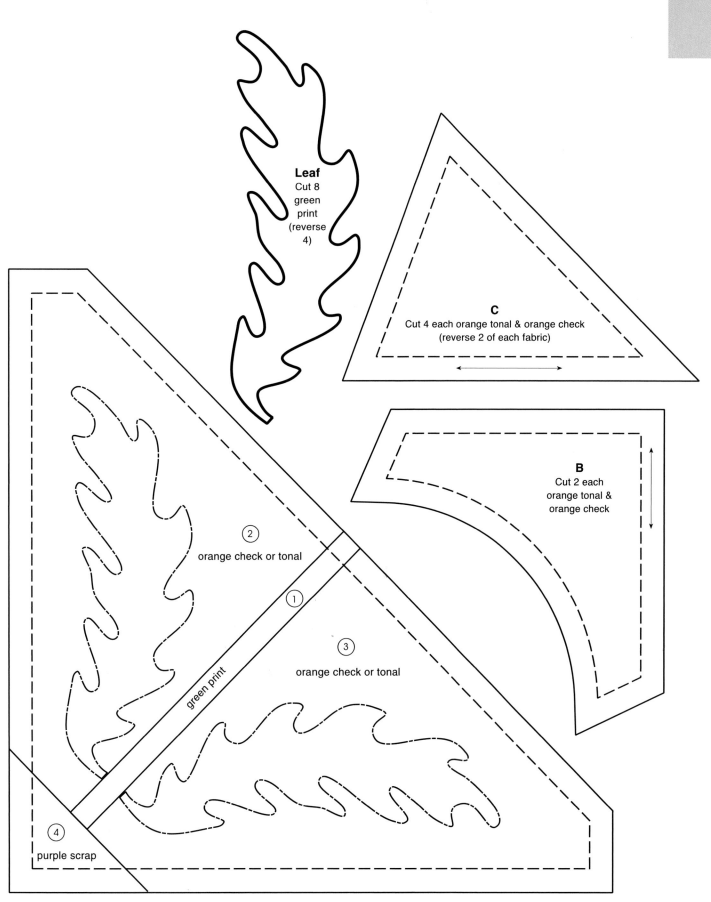

Leaf
Cut 8
green
print
(reverse
4)

C
Cut 4 each orange tonal & orange check
(reverse 2 of each fabric)

B
Cut 2 each
orange tonal &
orange check

② orange check or tonal

① green print

③ orange check or tonal

④ purple scrap

Section D Paper-Piecing Pattern
Make 4 copies

November Oak & Pod Blossom Wreath

An appliquéd leaf wreath makes the perfect November banner.

PROJECT SPECIFICATIONS
Skill Level: Advanced
Project Size: 15" x 15"

MATERIALS
- Scraps rust/green batik, brown print, rust tonal, brown dot, burgundy mottled, red/black/cream stripe and black tonal
- ⅛ yard rust batik
- ⅛ yard brown calico
- 1 fat quarter tan print
- ¼ yard taupe print
- Backing 20" x 20"
- Thin batting 20" x 20"
- All-purpose thread to match fabrics
- Clear nylon monofilament
- Contrasting quilting thread
- Template plastic
- ¼ yard fusible web
- ¼" bias bar
- Erasable marker or pencil
- Basic sewing tools and supplies

Instructions

1. Prepare all appliqué pieces referring to Basic Appliqué on page 60.

2. Prepare the F template using pattern given; cut as directed.

3. Cut one 11⅛" x 11⅛" A square tan print.

4. Cut two 3⅞" x 3⅞" squares tan print; cut each square in half on one diagonal to make four D triangles.

5. Cut two 1" x 11⅛" B strips and two 1" x 12⅛" C strips brown calico.

6. Cut four 2½" x 2½" E squares brown calico.

7. Cut (16) 1" x 6" bias strips rust batik.

8. Cut two 2¼" by fabric width strips taupe print for binding.

Completing the Center Panel

1. Fold and crease A to mark the vertical and horizontal centers.

2. Transfer the ¼ wreath positioning diagram to each creased quarter of A using the erasable marker or pencil.

3. Arrange and fuse appliqué shapes on the marked sections referring to the ¼ wreath positioning diagram, project photo and the Placement Diagram for positioning.

4. Machine-appliqué pieces in place to complete the center panel referring to Basic Appliqué on page 60.

Completing the Quilt

1. Transfer the bias lines to the right sides of F and FR.

2. Fold each bias strip in half with wrong sides together along the length; adjust machine stitch length to 12–15 stitches per inch. Stitch a ³⁄₁₆" seam allowance on each strip to form a tube as

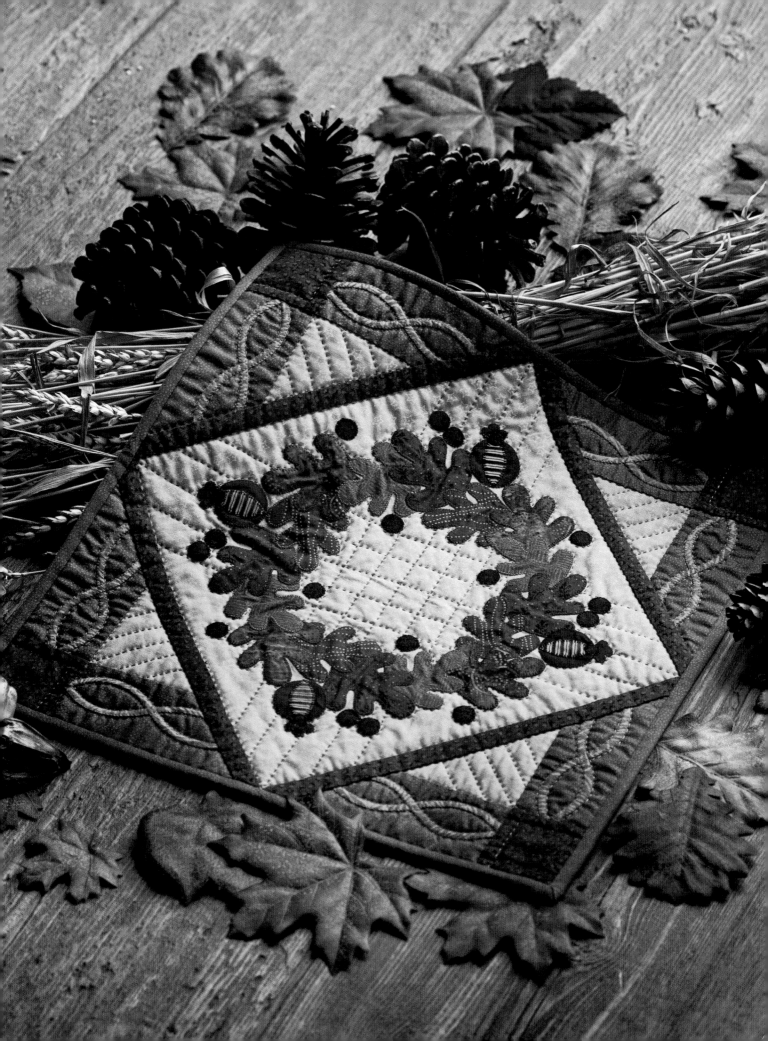

shown in Figure 1; trim seam allowance slightly narrower than the tube width.

Figure 1

3. Insert the ¼" bias bar inside one tube, moving seam allowance to the center of one side as shown in Figure 2; press to complete the bias strip. Repeat for all bias strips.

Figure 2

4. Position a bias strip along the marked lines on each F and FR piece; baste to hold in place.

5. Machine-appliqué in place using clear nylon monofilament referring to Basic Appliqué on page 60.

6. To complete one corner unit, sew F to D as shown in Figure 3; press seam toward F.

Figure 3

7. Sew E to FR as shown in Figure 4; press seam toward FR.

Figure 4

8. Sew the FR-E unit to the D-F unit to complete one corner unit as shown in Figure 5; press seam toward FR-E. Repeat to complete four corner units.

Figure 5

9. Sew a B strip to opposite sides and C strips to the remaining sides of the center panel; press seams toward strips.

10. Center and sew a corner unit to each side of the center panel; press seams toward the corner units.

11. Trim the B-C corners even with the corner units on each side, leaving ¼" beyond the corner of A as shown in Figure 6.

Figure 6

12. Refer to Completing Your Quilt on page 64 and to the Placement Diagram for quilting suggestions to finish the quilt. ■

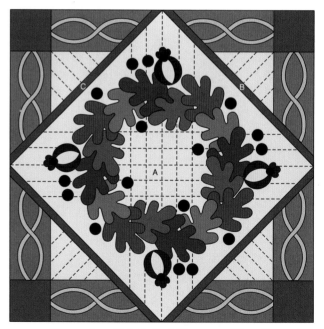

November Oak & Pod Blossom Wreath
Placement Diagram
15" x 15"

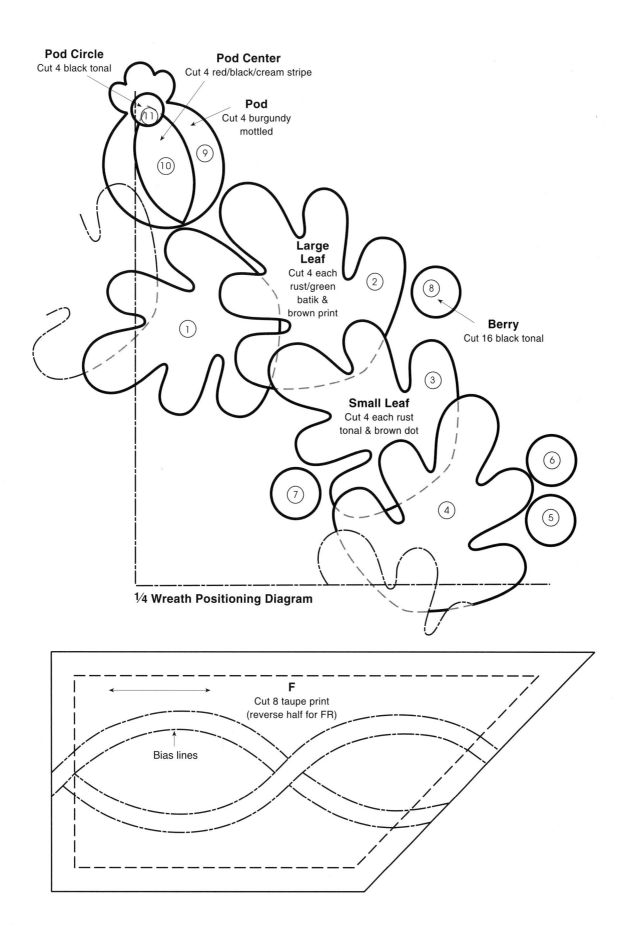

Pod Circle
Cut 4 black tonal

Pod Center
Cut 4 red/black/cream stripe

Pod
Cut 4 burgundy
mottled

⑪

⑩ ⑨

**Large
Leaf**
Cut 4 each
rust/green
batik &
brown print

②

⑧

Berry
Cut 16 black tonal

①

③

Small Leaf
Cut 4 each rust
tonal & brown dot

⑥

⑦

④

⑤

¼ **Wreath Positioning Diagram**

F
Cut 8 taupe print
(reverse half for FR)

Bias lines

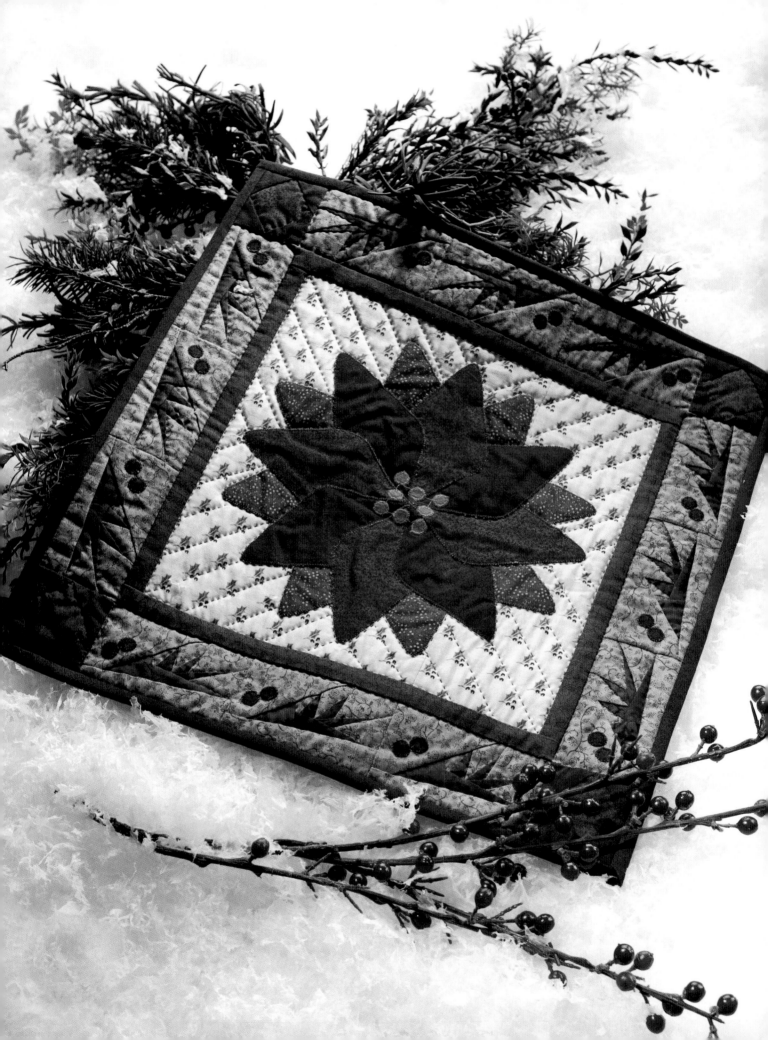

December
Poinsettia & Pine

The red and green colors of the season are reflected in this appliquéd and paper-pieced banner.

PROJECT SPECIFICATIONS
Skill Level: Advanced
Project Size: 15" x 15"

MATERIALS
- Scraps green speckled, deep burgundy mottled and gold solid
- ⅛ yard brown tonal
- ⅛ yard dark green mottled
- ⅛ yard red tonal
- Fat quarter cream print
- ¼ yard deep red mottled
- ¼ yard pale sage print
- Backing 20" x 20"
- Thin batting 20" x 20"
- All-purpose thread to match fabrics
- Contrasting quilting thread
- ¼ yard fusible web
- Erasable marker or pencil
- Basic sewing tools and supplies

Instructions
1. Make copies of the section D and E paper-piecing patterns as directed. Cut pieces referring to Basic Paper Piecing on page 62.

2. Prepare appliqué pieces referring to Basic Appliqué on page 60.

3. Cut one 10½" x 10½" A square cream print.

4. Cut two 1" x 10½" B strips and two 1" x 11½" C strips brown tonal.

5. Cut two 2¼" by fabric width strips deep red mottled for binding.

Completing the Center Panel
1. Fold and crease A to mark the vertical and horizontal centers.

2. Transfer the ¼ positioning diagram to each creased quarter of A using the erasable marker or pencil.

3. Arrange and fuse appliqué shapes on the marked sections referring to the Placement Diagram for color positioning.

4. Machine-appliqué pieces in place to complete the center panel referring to Basic Appliqué on page 60.

Completing the Quilt
1. Complete 12 paper-pieced D sections and four paper-pieced E sections referring to Basic Paper Piecing on page 62.

2. Position, fuse and machine-appliqué two pine berries on each paper-pieced D section, referring to the pattern for positioning and to Basic Appliqué on page 60.

3. Sew a B strip to the top and bottom and C strips to opposite sides of the center panel; press seams toward B and C strips.

4. Join three paper-pieced D sections as shown in Figure 1 to make a side strip; press seams in one direction. Repeat to make four side strips.

Figure 1

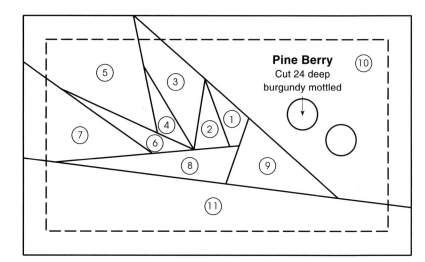

Section D Paper-Piecing Pattern
Make 12 copies
Use pale sage print for pieces 1, 3, 5, 7, 10 & 11
Use dark green mottled for pieces 2, 4, 6, 8 & 9

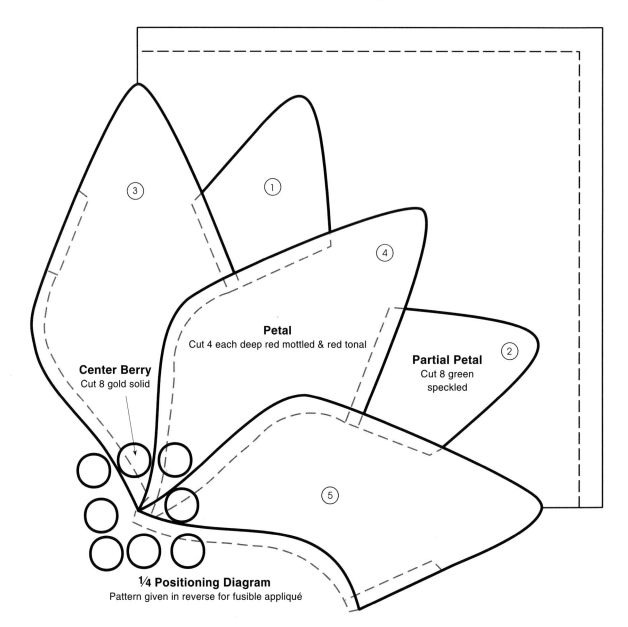

Pine Berry
Cut 24 deep burgundy mottled

Petal
Cut 4 each deep red mottled & red tonal

Partial Petal
Cut 8 green speckled

Center Berry
Cut 8 gold solid

¼ Positioning Diagram
Pattern given in reverse for fusible appliqué

5. Sew a side strip to opposite sides of the center panel referring to the Placement Diagram for positioning of strips; press seams toward B strips.

6. Sew a paper-pieced E section to each end of each remaining side strip; press seams toward the E sections.

7. Sew the E/side strips to the remaining sides

of the center panel to complete the top; press seams toward C strips.

8. Refer to Completing Your Quilt on page 64 and to the Placement Diagram for quilting suggestions to finish the quilt. ■

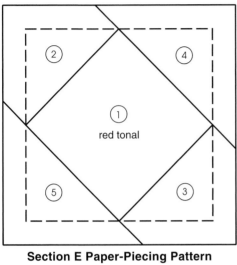

Section E Paper-Piecing Pattern
Make 4 copies
Use deep red mottled for unmarked pieces.

December Poinsettia & Pine
Placement Diagram
15" x 15"

April Spring Breeze Tulips

Continued from page 20

8. Lay out the pieced units with two G triangles as shown in Figure 6; join to complete a side strip. Press seams in one direction. Repeat to make four side strips.

Figure 6

9. Sew a side strip to the E sides of the pieced center referring to the Placement Diagram for positioning of strips; press seams toward E strips.

10. Sew a Heart block to each end of the

remaining two side strips as shown in Figure 7; press seams toward side strips.

Figure 7

11. Sew the Heart/side strips to the remaining sides of the pieced center referring to the Placement Diagram for positioning; press seams toward D strips.

12. Sew J strips to the top and bottom and K strips to opposite sides of the pieced center to complete the pieced top; press seams toward J and K strips.

13. Refer to Completing Your Quilt on page 64 and to the Placement Diagram for suggested quilting to finish the quilt. ■

Display Board for Flower Banners

SUPPLIES
- 5½" x ¾" pine stock: one 17⅞" (for frame top)
- 1¼" x ¾" pine stock: two 15¼" (for frame sides), one 17⅞" (for frame bottom), one 12½" (for faux bracket)
- Saw
- Wood glue
- Frame corner cleats
- Sandpaper: medium- and fine-grit
- Router with ¼" straight bit
- Wood chisel and mallet
- Beadboard panel approx. 16" x 16"
- Bulletin board cork strip: ¼" thick x 1¼" wide x 12" long
- Drill and bit (to attach knobs and dowel pins)
- 2 small pine knobs
- Acrylic paint: cream
- Water-based stain: oak
- 2 (¼") dowel pins
- Vinyl adhesive lettering, or brown acrylic paint and fine paintbrush
- Hanging cleat
- Short steel-head straight pins

Instructions

1. To shape frame top, make a guide mark 2" from upper corners of top piece and connect with straight edge to top center mark, as shown in diagram. Cut away corners with saw.

2. Referring to diagram, join frame sides and bottom to frame top with wood glue and cleat corners. Sand with medium- then fine-grit sandpaper until smooth and blemish free. ***Note:*** *For antique edging, sand away corners on all pieces.*

3. Rout a ¼"-wide x ¼"-deep rabbet around the back inside edge of the frame; square the corners using a wood chisel and mallet. Measure rabbeted opening; trim beadboard panel to fit; glue in place. Glue cork strip in place, centered at top edge of beadboard.

4. Mark and drill holes for knobs centered in the width of the faux bracket, approximately 2¾" from each end; attach knobs and glue in place.

5. Apply two coats of acrylic paint to entire piece (including cork tack strip), letting dry after each coat. Antique by brushing on then wiping off stain until desired effect is achieved.

6. Clamp faux bracket onto front of frame top, centered side to side with bottom edges flush. Turn frame face down and drill holes for dowel pins through the back of the frame top and

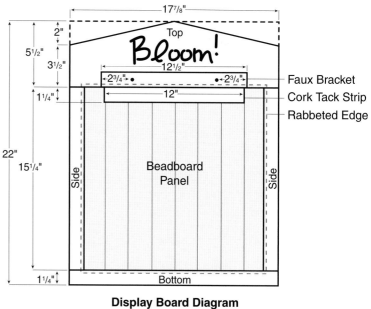

Display Board Diagram

halfway into the thickness of the faux bracket. **Note:** *Position holes between knob placement.* Insert and glue dowel pins in holes; let dry. Remove clamps.

7. Apply adhesive vinyl lettering above bracket. Attach hanging cleat to back side.

8. Mount quilt by pinning to cork strip with short pins. ■

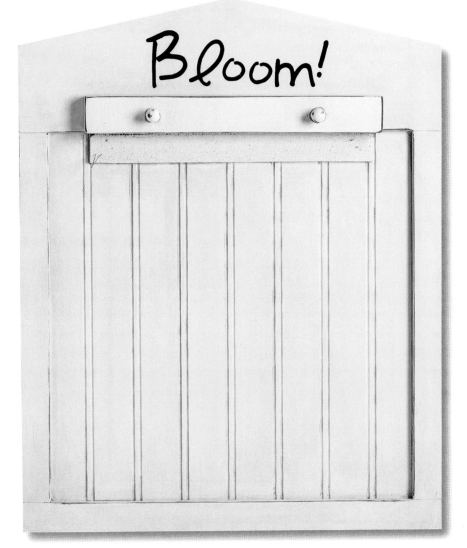

General Instructions

Here are a few bits of basic information you should know. Use a ¼" seam allowance for all piecing, unless otherwise specified. These patterns include rotary-cutting instructions wherever possible. Templates are given where the use of quick-cutting instructions are not feasible.

Quick-piecing methods are recommended to make best use of time and resources.

Specific instructions follow for paper piecing and appliqué because many patterns in this book use these methods. General instructions are also given for completing your quilt.

Basic Appliqué

Full-size patterns for the appliqué designs are included for each quilt. Use your favorite method of hand or machine appliqué to complete the designs. Basic information and hints to help you successfully complete the appliqué are given here. Read through these instructions before starting any project and refer to them as necessary. Any special instructions for a specific project are listed with the pattern.

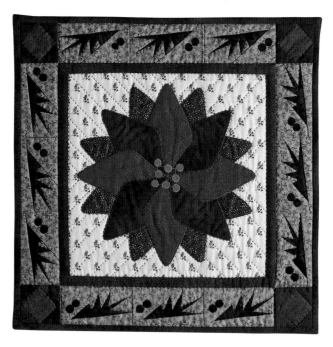

Different line styles on the drawings identify overlapped pieces, placement of pieces or pattern sections and the outside edge of each piece. Figure 1 shows each line included in these patterns and an example of its use.

Line Key

 - - - Overlap
 -·-·- Placement
 ───── Outside edge

All patterns in this book are given in reverse for machine appliqué.

Hand Appliqué

• Reverse all appliqué pieces given in this book for hand appliqué unless otherwise noted.

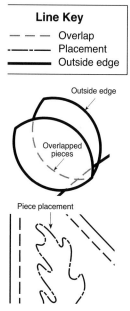

Outside edge

Overlapped pieces

Piece placement

Figure 1

• When preparing templates for hand appliqué, be sure to include the section of a piece that will be overlapped by an adjacent piece. This section is outlined with gray dashed lines on the pattern as shown in Figure 2.

Figure 2 **Figure 3**

• Fold the appliqué background piece and press to mark the center as shown in Figure 3. Lightly trace the pattern on the background square using an erasable marker or pencil, aligning the creased line(s) on the background square with the center of the pattern as shown in Figure 4.

Figure 4

• For traditional hand appliqué, prepare a finished-size template from plastic. Trace the plastic template on the chosen fabric's right side, allowing about ½" between pieces as shown in Figure 5. Cut out the pieces, adding a ⅛"–¼" seam allowance to all edges except those that will be overlapped by another piece. Turn under and hand-baste the seam allowance of each piece or leave seam allowances to needle-turn as you appliqué the pieces.

Figure 5

• For freezer-paper appliqué, photocopy or trace the design on a sheet of paper. Place the design side against a light box or bright window and trace the pieces on the paper side of freezer paper. Press the freezer-paper templates on the wrong side of the chosen fabric with a hot, dry iron, leaving space between pieces as shown in Figure 6. Cut out the pieces, adding a ⅛"–¼" seam allowance to all edges except those that will be overlapped by another piece. Press the seam allowance under using the edge of the freezer paper as a guide. Hand-baste in place through all layers to hold.

Figure 6 **Figure 7**

• The circled numbers determine the order in which the pieces will be appliquéd to the background. Beginning with the lowest number, pin the pieces in place on the background in numerical order, overlapping pieces as indicated on the pattern as shown in Figure 7.

• Blind-stitch the pieces in place, using thread to match the appliqué piece and turning under seam allowances, if necessary. Remove seam allowance basting.

• For freezer-paper pieces, cut a small slit in the background behind each appliquéd piece as shown in Figure 8. Remove the freezer-paper piece using small tweezers.

Figure 8 **Figure 9**

• If darker pieces show through lighter top pieces, cut a slit through the background behind the darker piece and trim away the section of the darker piece that is overlapped by the lighter piece, leaving only a narrow seam allowance as shown in Figure 9. Trim the darker portion of the seam allowance, if necessary.

• Use a press cloth to press the appliquéd design.

Machine Appliqué

• Fold the appliqué background piece and press to mark the center as for Hand Appliqué.

• Fuse lightweight fusible interfacing to the wrong side of any light-color fabrics to prevent shadowing of darker fabrics, if necessary.

• Trace the pieces to be cut from each fabric in a group on the paper side of fusible web, leaving a space between each fabric group and marking the number of each piece on the traced outline as shown in Figure 10. Be sure to add extra when one piece is overlapped by another as indicated by the gray dashed lines on the patterns.

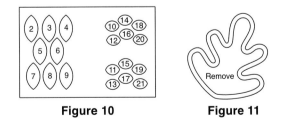

Figure 10 **Figure 11**

• Trim away the fusible web in the center of the medium-to-large pieces, leaving a narrow edge of fusible web around the outer edge of the shape as shown in Figure 11. This will eliminate much of the stiffness common with fusible appliqué.

- Roughly cut out each group of pieces, leaving a margin around each group. Fuse each group to the wrong side of the chosen fabric following the manufacturer's instructions. Cut out each piece on the drawn line.

- Beginning with the lowest-numbered piece, remove the paper backing and arrange the pieces on the background in numerical order, overlapping pieces as indicated on the pattern. When satisfied with the arrangement, fuse pieces to the background fabric.

- You may find it easier to fuse small sections of a pattern that has many pieces. Arrange one section in numerical order and fuse the pieces as shown in Figure 12. Move on to the next section and do the same. Continue fusing sections until the design is complete. Just remember to not only fuse the pieces within a section in numerical order, but to also fuse the pieces for the whole design in numerical order. Otherwise, you may find that you have fused a piece in one section that should have overlapped a piece in another section.

Figure 12

- Use all-purpose thread, machine-embroidery thread or rayon thread to closely match each appliqué piece in the top of your machine and all-purpose thread to match the background in the bobbin. Blanket-stitch around the edges of each piece using a close narrow-width stitch. Adjust your machine as necessary to prevent the bobbin thread from pulling to the top of your block. Pull the thread ends to the back of the stitched piece; tie off ends and trim.

- Use a press cloth to press the appliquéd design.

Basic Paper Piecing

Blocks with many different shapes joined with straight seams are good candidates for paper piecing. Rather than make lots of templates that are used only once,

the fabric is stitched onto a paper foundation for the block or block section. Full-size patterns for each section are included for paper-pieced blocks. Basic information and hints for paper piecing are given here.

Choosing Foundation Paper

- Always remember that your stitched piece will be the reverse image of the printed pattern. You will place the fabric on the back, unprinted side of the paper pattern. Often patterns must be traced or made in reverse to be used as paper-piecing patterns. The patterns given here have already been reversed to allow easy photocopying or tracing.

- Choose paper for the patterns that will not tear as you stitch, but that will tear away easily when all stitching is complete. Choose paper that will allow you to see through from the back to the printed side with only the light from your sewing machine to assist you. It does not have to be transparent.

- You may purchase paper specially designed for paper piecing. Most can be used in a photocopier or computer printer. It is usually translucent enough to allow you to see the stitching lines from the back side, and it can be removed when your block is complete without damaging the stitches.

- You may use other paper that you have on hand or that is readily available. Tracing paper, multiuse paper and photocopier paper are possible choices. The large sheets of lightweight buff-colored paper used for packing work well and help with recycling. Its porous quality allows the pattern lines to bleed through to the fabric side, making placement easier. It tears away easily without pulling the stitches. The large size accommodates 12" or larger blocks without combining sheets.

- Test paper for stitching stability by sewing a line with your machine set at 18–20 stitches per inch. The stitches should perforate the paper without creating a cut along the stitching line. Now, try to tear the paper away from the line of stitches. It should come away easily without stretching or distorting the stitches and without leaving shreds of paper behind.

Preparing Patterns

• Paper-piecing patterns may be photocopied for stitching. Check that the photocopied image is the same size as the original. Many photocopiers distort the image. A change in size, however slight, may make a difference in the overall piecing of your block. Also, check the photocopied pattern to be sure the ink will not come off on your iron when pressing pieces while sewing.

• To make the patterns by hand, use a permanent pen or pencil to exactly trace the patterns. Beware of any ink that may run. In heavily stitched areas, the paper foundation may not be entirely removed. Future washing may cause any ink left within the stitching to run.

• Cut out each section, leaving a margin beyond the heavy outer line as shown in Figure 13.

Figure 13

Stitching Patterns

1. Begin with a sharp needle in your sewing machine. Shorten your stitch length to 18–20 stitches per inch. This shorter stitch length allows for easy removal of the paper without stretching the stitches.

2. Use thread to match fabrics or a neutral color that will blend with all the fabrics.

3. Cut a piece of fabric for area 1. The piece should be larger than the area to allow for seam allowance all around the area. If the pattern has unusual-angled shapes or shapes with very long points, it is easier to precut the pieces using a pattern. Make an extra copy of the section pattern and cut it apart on the solid lines as shown in Figure 14. Use each piece to rough-cut a fabric piece as shown in Figure 15. Cut the pieces larger all around than the paper piece to allow for seam allowance and to allow a bit of leeway in arranging the pieces before stitching.

Figure 14 **Figure 15**

4. Place fabric to cover area 1 on the paper pattern with wrong side of fabric against the unmarked side of the paper, allowing fabric to extend at least ¼" into adjacent areas as shown in Figure 16.

Figure 16 **Figure 17**

5. Place fabric for area 2 right sides together with fabric 1 on the 1-2 edge as shown in Figure 17; pin along the 1-2 line. Fold fabric 2 over to cover area 2, allowing fabric to extend at least ¼" into adjacent areas as shown in Figure 18. Adjust fabric if necessary. Unfold fabric 2 to lie flat on fabric 1.

Figure 18 **Figure 19**

6. Flip paper pattern; stitch on the 1-2 line, beginning and ending 2 or 3 stitches into adjacent areas as shown in Figure 19. Stitch to (or beyond) the outside heavy solid line on outer areas as shown in Figure 20.

Figure 20 **Figure 21**

7. Trim the 1-2 seam allowance to ⅛"–¼" as shown in Figure 21. Fold fabric 2 to cover area 2; lightly press with a warm dry iron.

8. Continue to add fabrics in numerical order to cover the paper pattern as shown in Figure 22. Check that each piece will cover its area before stitching. The very short stitches are hard to remove and often cause a tear in the paper pattern. Should this happen, place a small piece of transparent tape over the tear to continue to use the pattern. Do not use this quick fix frequently, as it makes removal of the paper difficult.

Figure 22

9. Pin outside fabric edges to the paper pattern. Trim paper and fabric edges even on the outside heavy solid line as shown in Figure 23.

Figure 23

10. Place block sections with fabric sides together. Stick a pin through both sections at each end of the dashed seam line to be sure the lines on both sections match as shown in Figure 24. Stitch along the dashed seam lines to join the sections as shown in Figure 25. Remove paper from seam allowance area only. Press seam to one side.

Figure 24　　　　**Figure 25**

11. Join all block sections to complete the block.

12. Leave paper pattern intact until the block is joined with other quilt pieces.

Completing Your Quilt

1. Mark quilting lines onto the finished top referring to the photo of the finished quilt for quilting suggestions.

2. Sandwich the batting between the completed top and prepared backing; pin or baste layers together to hold. Note: *If using basting spray to hold layers together, refer to instructions on the product container for use.*

3. Quilt as desired by hand or machine; remove pins or basting. Trim excess backing and batting even with quilt top.

4. Join binding strips on short ends to make one long strip. Fold the strip in half along length with wrong sides together; press.

5. Sew binding to quilt edges, mitering corners and overlapping ends. Fold binding to the back side and stitch in place to finish. ■

E-mail: Customer_Service@whitebirches.com

A Year of Flower Blocks is published by House of White Birches, 306 East Parr Road, Berne, IN 46711, telephone (260) 589-4000. Printed in USA. Copyright © 2007 House of White Birches.

HOUSE of WHITE BIRCHES PUBLISHERS SINCE 1947

RETAIL STORES: If you would like to carry this pattern book or any other House of White Birches publications, call the Wholesale Department at Annie's Attic to set up a direct account: (903) 636-4303. Also, request a complete listing of publications available from House of White Birches.

ISBN: 978-1-59217-162-0
1 2 3 4 5 6 7 8 9

STAFF
Editors: Jeanne Stauffer, Sandra L. Hatch
Associate Editor: Dianne Schmidt
Technical Artist: Connie Rand
Copy Supervisor: Michelle Beck
Copy Editors: Sue Harvey, Nicki Lehman
　Mary O'Donnell, Judy Weatherford
Graphic Arts Supervisor: Ronda Bechinski

Graphic Artists: Debby Keel,
　Edith Teegarden
Art Director: Brad Snow
Assistant Art Director: Nick Pierce
Photography: Tammy Christian, Don Clark,
　Matthew Owen, Jackie Schaffel
Photo Stylists: Tammy Nussbaum,
　Tammy M. Smith